*Nature's Ultimate Anti-Cancer Pill:*

# THE IP$_6$ WITH INOSITOL QUESTION & ANSWER BOOK

*How to Use Nature's
Ultimate Anti-Cancer Pill for the
Prevention and Treatment of
All Forms of Cancer*

D1604212

BY

L. STEPHEN COLES, M.D., PH.D.

AND

DAVID STEINMAN

ISBN 1-893910-00-8

First Printing, March 1999

Published by Freedom Press
1801 Chart Trail
Topanga, CA 90290

Bulk Orders Available:
(310) 455-2995 or (310) 455-8952
E-mail: sales@freedompressonline.com

Book Design: Bonnie Lambert

# Acknowledgements

*We wish to acknowledge the work of Dr. AbulKalam M. Shamsuddin, M.D., Ph.D. of the University of Maryland School of Medicine, Drs. Ivana Vucenik, Kosaku Sakamoto of Gunma University, Japan, Raxit Jariwalla, formerly of the Linus Pauling Institute of Science and Medicine, Lee Wattenberg of the University of Minnesota, F. Grases of the University of the Balearic Islands and other medical scientists who have painstakingly and carefully documented $IP_6$ with inositol to be a scientifically validated natural anti-cancer pill. We also wish to acknowledge the many letters and E-mails that we have received at **The Doctors' Prescription for Healthy Living** and the brave and good persons with cancer who have contributed to this book.*

# CONTENTS

Contents

# Contents

# INTRODUCTION

DAVID STEINMAN AND I WERE HONORED to be the first medical reporters to break the $IP_6$ with inositol story in the popular press when we began publishing our reports in 1998 in *The Doctors' Prescription for Healthy Living*. Since then we have received an overwhelming response from readers, many of whom have cancer or know or love someone who does. As the first E-mails began reaching us, we thought that, well, this is interesting. Here are a few letters from people with cancer who want to know more about this amazing substance with its impeccable scientific studies, but as more and more E-mails poured in by the hundreds, we knew that we were riding the crest of a giant wave of enthusiasm. It was a saddening enthusiasm because the people writing us were desperate to live, to survive their cancer, and they needed help. $IP_6$ with inositol seemed to offer that help.

In retrospect, we are not surprised. Tragically, the prevention and treatment of cancer has become of widespread, intense importance to millions of Americans today, and $IP_6$ with inositol, with its strongly scientifically documented anticancer activity and complete safety, probably ought to be used by every American today. We truly believe that if it were put into use by all persons living in America and elsewhere today, our cancer rates would reflect a significant decrease in

both incidence and mortality. That is not to say that IP$_6$ with inositol alone is the total answer to the cancer epidemic, but it is, in our opinion, part of the answer. We wish it were not necessary. We wish that faulty genes, poor diet, pervasive environmental pollution, tobacco, carcinogens in consumer products and foods and beverages, and our decreasing ozone layer (that allows more solar radiation to penetrate our environment) were not so much part of our lives today to the extent that they have become, and that our cancer risks were decreasing instead of increasing. But they are. As such, IP$_6$ with inositol, a cancer killer, is a hired hand whom we need to position on our side.

The National Cancer Institute (NCI) is responsible for directing the nation's "war" on cancer. Even so, from 1950 to 1989, the overall incidence of cancer in the United States (adjusted for the aging population) rose by approximately 44 percent, with lung cancer because of smoking accounting for less than a quarter of this increase. Age-adjusted incidence rates for breast cancer and male colon cancer for the general U.S. population have increased by over 50 percent, whereas the rates for some less common cancers, such as malignant melanoma, certain lymphomas, and male kidney cancer have increased by over 100 percent. Childhood cancer has also increased by about 20 percent. Higher cancer rates still are seen for people living in highly urbanized and industrialized counties (in the vicinity of petrochemical, mining, smelting, and nuclear weapons plants), and for workers in these industries. Today, greater than one in three Americans will be stricken with cancer in their lifetime and greater than one in four will die. Cancer has overtaken heart disease as the leading killer of *middle-aged* Americans, and the baby boom generation is at a far higher cancer risk than its grandparents' generation. Pollution and our personal lifestyle and dietary habits are also wreaking havoc on our cellular health. Adenocarcinoma of the esophagus has increased 350 percent among white men over the last 20 years. As reported in the journal *Cancer*, annual cases rose from 0.7 per 100,000

in 1974-76 to 3.2 per 100,000 in 1992-94. Nearly 90 percent of patients with esophageal cancer die within five years of contracting the disease. The study was conducted by researchers from the NCI and the International Epidemiology Institute. They speculate that the reasons for this sharp increase may include smoking and obesity.

In two major books that my co-author David Steinman has written with international cancer expert Samuel S. Epstein, M.D., it has been observed that the U.S. National Cancer Institute has taken a decidedly indifferent, if not hostile, view toward prevention despite the fact that the war on cancer is clearly being lost.[1,2] The NCI continues to lead the public and Congress into believing that "we are winning the war against cancer," with "victory" possible only given more time and money. The NCI and the American Cancer Society (ACS) also insist that there have been major advances in the treatment and cure of cancer, that there has been no increase in cancer rates (except for lung cancer, which is attributed exclusively to smoking). Yet, the facts show just the contrary. For example, a recent Swedish study found that baby boomers face a higher risk of cancer than did their great-grandparents. The study of nearly 840,000 cases in all groups reported to the Swedish government since 1958 revealed that the risk of developing cancer was almost three times higher in men born in the 1950s than in those born in the 1880s, and for women, the risk was twice as high. These differences held true even after accounting for smoking-related cancer. Despite growing evidence that cancer is caused by exposure to environmental carcinogens, NCI—which could direct millions of dollars into truly effective cancer-prevention programs that would focus on providing important information on cancer hazards in the environment and removing the environmental causes of this disease—continues its unsubstantiated claims that "victory" is only a "cure" away.

More recently, according to a September 1994 NCI report "Cancer at the Crossroads," Dr. Paul Calabresi, Chairman of the National

Cancer Advisory Board, admitted that the war against cancer has stalled and that new direction is urgently needed. But instead of seeking to direct its own massive funding into eliminating preventable causes of the disease, NCI requested still more money for moving "cures" for the disease from the laboratory to the doctor's office, and also requested appointment of a Cabinet-level official to coordinate a national effort to win the war against cancer. In effect, NCI used the ploy of shifting the blame for its failing policies to Congress, arguing that if the war continues on its losing course, it would now be the "burden" of Congress for its failure to provide additional and massive funding.

In March 1998, NCI, together with the ACS and Centers for Disease Control and Prevention, announced that for the first time in 20 years cancer rates were declining in America, based on a study first reported in the journal *Cancer*. The claimed reversal for cancer mortality rates, however, was largely due to a reduction in lung cancer deaths from smoking in men and to improved access to health care rather than to any improvement in treatment and survival rates; the highly acclaimed decreased incidence of prostate cancer was most likely a result of decreased use of PSA screening tests during the early 1990s. What's more, the same study reported sharp increases in uterine cancer, melanoma, and non-Hodgkin's lymphoma, each of which is clearly related to environmental factors, including industrial pollution and agricultural pesticides used in food production as well as women's use of commercial hair coloring products with specific phenylenediamine-based dyes. Moreover, there was no decline in breast cancer rates, which remained unchanged at their current high level. Curiously, no reference at all was made to testicular cancer in young adults nor to childhood cancer, whose rates have dramatically increased in recent decades and which are also clearly associated with toxic chemical exposures.

*Introduction*

Cancer now strikes one in two men and one in three women, up from an incidence of one in four a few decades ago. It is a dismal record, and everyone has felt the pain of cancer.

With this in mind, people are anxious to find methods for preventing and successfully treating cancer. $IP_6$ with inositol is a natural, nontoxic substance that is sure to help many people in this quest.

Fortunately, the anti-cancer pill $IP_6$ with inositol is receiving high level attention these days in Washington—thanks to intense interest by persons both on, and associated with, the Congressional Government Reform and Oversight Committee.

According to our sources, Indiana Congressman Dan Burton, chairman of the Government Reform and Oversight Committee, met with NCI Director Dr. Richard Klausner in November 1998. Their topic of discussion? How to fast track $IP_6$ with inositol to clinical trials.

**CONGRESSMAN'S PERSONAL INTEREST**

Congressman Burton, whose wife was diagnosed with breast cancer, is a strong proponent of complementary medicine. His position is that public funding for clinical trials should be made available when therapies or natural agents show real healing promise. Meanwhile, other persons on the Hill who have known cancer are also lobbying behind the scenes to expedite clinical trials.

**$IP_6$ WITH INOSITOL'S BRIGHT FUTURE NOT WITHOUT CHALLENGES**

The future for $IP_6$ with inositol is promising but not without strong challenges. For over twenty-five years, NCI and ACS policies and priorities have remained resistant to making prevention

a major priority. The present leadership of both the NCI, Richard Klausner, and the parent National Institutes of Health, Harold Varmus, are more than ever committed to basic molecular biology research and to indifference to cancer prevention. This mindset will make the road ahead challenging. But Dr. AbulKalam M. Shamsuddin, one of the world's leading authorities on IP$_6$ with inositol, Congressman Burton and other members of the House Leadership, particularly new House Speaker Rep. J. Dennis Hastert of Illinois, remain committed to equal funding for clinical trials for promising natural agents. We submit that no potential anti-cancer pill, whether natural or synthetic, has received as much research and has as much solid experimental evidence (performed at some 12 different laboratories worldwide) as IP$_6$ with inositol.

## NCI REFORM ALSO IMPORTANT

Still, cancer is the only disease for which Government advocates curing, not controlling and preventing. The conflicts of interest are so blatant that in 1992, under the leadership of Dr. Epstein, a group of sixty distinguished scientists, including Eula Bingham, Ph.D., former Assistant Secretary of Labor, Occupational Safety and Health Administration, David Rall, M.D., Ph.D., former assistant Surgeon General, and Anthony Robbins, M.D., past director of the National Institute for Occupational Safety and Health, demanded that Government hold the National Cancer Institute accountable for its lavish funding. The scientists demanded that at least fifty percent of the National Cancer Institute's two billion dollar budget be immediately shifted and spent to control and prevent cancer.

One proposal that has been circulated on the Hill is that Congressional appropriation committees should be urged to progressively allocate ten percent of the NCI's annual budget for exclu-

---

## WE NEED YOUR HELP

If you're using $IP_6$ with inositol and have cancer or you are doctor whose patients are using this natural anti-cancer agent, please send us information on your experience with $IP_6$ with inositol and how it has helped. It is extremely important now that we gather as much anecdotal and clinical information as possible in preparation for the challenges that lay ahead. My E-mail address is scoles@grg.org

Let your Congressional representatives in the House and Senate know about $IP_6$ with inositol. Urge them to support funding for a clinical trial of this promising natural agent. With greater than one in three Americans at risk for cancer and with no magic bullet in sight, we need these clinical trials. We need you to plant the seed in Congress that it is important for NCI to fund these studies.

Write your Congressional representative in care of the House of Representatives, Washington, D.C. 20515 or your senator care of the United States Senate, Washington D.C. 20510.

---

sive use in primary prevention programs until prevention reaches the same level as all other programs combined.

In the meantime, I have personally sent a bottle of $IP_6$ with inositol to Congressman Burton, plus a copy of this book.

Because $IP_6$ with inositol is completely new and so many of our readers have important questions about $IP_6$ with inositol, what it can do for them, and how to use it both for prevention and treatment of cancer, we have collected many of the letters and E-mails that we have received. We have consulted many experts in order to effectively answer your questions and concerns.

But why, you might ask, publish a book about IP$_6$ with inositol now—before human clinical trials have been conducted. Isn't this sort of like science by "press conference" instead of waiting for more substantial results from human clinical trials? The answer is "because we cannot afford to wait that long." So long as it can be demonstrated to most physicians' satisfaction that IP$_6$ with inositol will do no harm and there are sufficient experimental studies and anecdotal human evidence from real patients that it has helped them—then we are ethically obliged to publish this data, even though we know it's not yet definitive. If you or someone you love has cancer, then it is our hope that you will be well served by the case-history information contained in this book.

It is our hope that this modest book will help to bring you the latest information on the many benefits of IP$_6$ with inositol not only for prevention and treatment of cancer but in many other areas of health, too.

*L. Stephen Coles, M.D., Ph.D.*
*February, 1999*

---

## SMART SHOPPER ALERT

This book and the results it reports pertains only to the patented form of IP$_6$ with inositol, which is sold under two trade names. **Cell Forté with IP$_6$ and Inositol** from Enzymatic Therapy is available at health food stores and natural product supermarkets. **Cellular Forté with IP$_6$ and Inositol** from PhytoPharmica is available through pharmacies and health professionals. All of the success stories and protocols reported in this book apply only to these brands. We can neither guarantee the safety nor efficacy of any other brand of either IP$_6$ alone or IP$_6$ with inositol that attempts to imitate the patented formula about which we are reporting.

*PART ONE*

# BACKGROUND INFORMATION ON $IP_6$ WITH INOSITOL— ANSWERS TO FAQS

Let's start with the most frequently asked questions concerning $IP_6$ with inositol.

$Q$ *What is $IP_6$ with inositol?*

$A$ $IP_6$ is inositol hexaphosphate, an all natural substance. It comes from grains and soybeans. It is a naturally occurring compound first identified in grains in 1855. $IP_6$ is the chief storage form of phosphorous for germinating seeds.

Inositol is a simple sugar alcohol (actually a closed ring consisting of six carbon atoms, a so-called *cyclohexane* derivative). Inositol is found naturally in fruits, vegetables, meat, milk, nuts, whole grains, and yeast. The value of this compound for human nutrition was not formally established until recently.

The hexaphosphoric ester of inositol is called *phytic acid*. The calcium and magnesium salt of phytic acid is called *phytin*, an abundant ingredient of the extracellular supporting material found in higher plants.

In nature, $IP_6$ and its relatives are powerful antioxidants that protect and preserve seeds so that they may remain viable for a long time. A seed

that is hundreds of years old and that still germinates does so because of the protective powers of IP$_6$. The IP$_6$ now available to the health-conscious public is taken from the bran portion of brown rice. It has been combined with inositol, a member of the B vitamin family, in a patented cancer-protective complex called **Cell Forté with IP$_6$ and Inositol**™ or **Cellular Forté with IP$_6$ and Inositol**™ that possesses synergistic effects.

$Q$ *Why should people take IP$_6$ with inositol?*

$A$ This formula has a proven track record of experimentally stopping cancer in its tracks. It is a cancer killer. An article in *Life Sciences* says a "striking anti-cancer action of IP$_6$ has been demonstrated . . ."[3] Since these early reports, we have begun to see remarkable clinical and anecdotal reports in which people whose doctors left them for dead, giving them only weeks or months to survive, have enjoyed prolonged survival rates and sometimes seemingly miraculous recovery from metastatic cancer. However, IP$_6$ with inositol is also a powerful tool for prevention and reducing cancer risk.

We all know that diets high in fiber and that regularly consuming green tea markedly reduce people's risks for all sorts of diseases, including cancer. That is why so many people today are eating whole grains and other fiber-rich foods and drinking more green tea than ever before. It is the IP$_6$ in grains and green tea, however, that is largely responsible for these foods' anticancer effects. The evidence at this time supports IP$_6$ with inositol's use to help prevent or reduce the risk of human colon, prostate, breast, and a wide range of other cancers, as well as aid in other disease conditions such as kidney stones and circulatory blockage. IP$_6$ with inositol suppresses tumors when added to the diet as a supplement in animal feeding studies, which is precisely how it is to be used as a cancer protective nutraceutical. As well, IP$_6$ with inositol may prove useful in cancer treatment. In fact, as we have mentioned and will continue to report throughout this book, early anecdotal reports are very promising.

Background Information on IP₆—FAQs

*Background Information on IP$_6$—FAQs*

$Q$ *How big is the IP$_6$ with inositol story?*

$A$It's huge. Dr. Anjana Challa reported in *Carcinogenesis* that it is the IP$_6$ in green tea that confers major anticancer effects. In fact, in head-to-head tests, IP$_6$ markedly outperforms green tea in reducing cell aberrations.[4] Make no mistake. Green tea is a powerful antioxidant and cancer preventive. Yet, IP$_6$ with inositol appears to be far more powerful. That's what makes the IP$_6$ with inositol story so remarkable. We believe that as the IP$_6$ with inositol story unfolds in the medical press, it will be bigger than green tea, which many medical and health experts believe to be one of the foods of the decade. We also think it will be bigger than grapeseed and pine bark extracts, two of the dietary supplements of the decade. We think it is that big a story.

$Q$ *What if a person has cancer now? Should they start to use IP$_6$ with inositol?*

$A$ *Of course. What are you waiting for?* One of the frequently asked questions about IP$_6$ with inositol is whether it can be used with active cancer, and, if so, at what dose, and what to expect. IP$_6$ with inositol is completely safe; it may very well help and will certainly do no harm. Some experts are already talking about its use in tumor treatment and we will report further on in this book on the successful use of IP$_6$ with inositol by medical doctors, health professionals and other cancer experts; however, there are no controlled human studies that we are aware of, and you should use IP$_6$ with inositol under the guidance of your attending doctor or health professional. Still, evidence shows IP$_6$ with inositol has a knack for turning cancerous cells back to normal. At first, we suspected that it would prove most useful in the earliest stages of malignancy, which is why we were recommending its daily use as a cancer preventive, but, based

on more recent reports, we believe its benefits may be far more pro-found and that they extend to late-stage and malignant, metastatic cancers. "The beneficial action of InsP$_6$ is not restricted to the prevention of tumor development but perhaps to treatment of existing cancers as well," reports the *Journal of Nutrition*.[5] We present additional findings on IP$_6$ with inositol and cancer treatment in Part II.

In one study, scientists exposed human liver and smooth muscle cancer cells to IP$_6$ with very significant tumor suppression or total regression. Other studies have shown dramatic reduction in lung tumors.

Dr. AbulKalam M. Shamsuddin, M.D., Ph.D., is working with several physicians, and Phase I clinical trials are expected to begin in mid-1999. However, although IP$_6$ with inositol has been studied primarily within experimental systems, we have collected some anecdotal and clinical evidence.

We can say, for example, that we have seen significant tumor regression in brain tumor patients who took IP$_6$ with inositol, based on magnetic resonance imaging, and in many other patients as discussed in Part II.

$Q$ *What is the evidence that IP$_6$ with inositol works?*

$A$ In 1989, Drs. Shamsuddin and Asad Ullah reported in *Carcinogenesis* that IP$_6$ prevented large intestinal cancer. IP$_6$ worked even after exposure to a carcinogen.[6]

In a study published in *Nutrition and Cancer*, IP$_6$ was tested for its benefits against a 20-percent bran diet. IP$_6$ demonstrated "significant reduction in tumor number, incidence, and multiplicity," wrote Ivana Vucenik and co-scientists.[7] "Thus IP$_6$, an active substance responsible for cereal's beneficial anti-cancer effect, is clearly more effective than 20% bran in diet. In practical terms, intake of IP$_6$ may be a more pragmatic approach than gorging enormous quantities of fiber for cancer prophylaxis."

In an experimental study, published in 1993 in *Cancer Letters*, breast tumors were reduced 40 percent.[8]

In 1995, Dr. Shamsuddin showed that IP$_6$ inhibits growth of prostate cancer cells. That year, writing in a publication of the American Institute of Nutrition, he said that the substance is "instantaneously taken up by malignant cells."[9] He also said that IP$_6$ is the secret for the power of high fiber diets to result in marked cancer reductions. Many other studies have confirmed its anticancer benefits. For example, Dr. Raxit Jariwalla, of the California Institute for Medical Research, wrote us this important letter regarding the anticancer (and cholesterol-lowering) effects of IP$_6$ with inositol. "I read with interest your article 'IP$_6$: The Anti-tumor Pill' in *The Doctors' Prescription for Healthy Living*. You may be interested to know that, although IP$_6$ has been demonstrated to prevent tumor development and perhaps to treat existing tumors, its anti-tumor activity is not limited to these effects alone. It extends to inhibition of tumor promotion as well. Thus, at about the same time that Dr. Shamsuddin and colleagues first reported the prevention of carcinogen-induced colon cancer, we published an experimental study in *Nutrition Research* in which it was shown that the addition of phytate (salt of phytic acid or IP$_6$) to a saturated-fat-enriched diet containing excess magnesium completely mitigated increases in tumor incidence and growth rate of experimentally induced fibrosarcomas.[10] In a subsequent study it was shown that phytate was capable of experimentally lowering serum lipid concentrations.[11] In an independent study, conducted in another laboratory, it was demonstrated that the addition of phytic acid to a high-fat diet containing high concentrations of calcium or iron, significantly diminished the cell proliferative (mitotic) activity potentiated by excess minerals in the mammary gland and colon of carcinogen-treated mice.[12] These and above results have provided support for a broad-spectrum anticancer effect of phytate/IP$_6$ and are consistent with the suggestion that the ability of IP$_6$ to bind minerals may be responsible for its anti-tumor promotion effect."

$Q$ *How does IP$_6$ work?*

$A$ In 1993, writing in the *Journal of Nutrition*, researchers showed that IP$_6$ is absorbed and distributed to various tissues in rats. It was shown to be well distributed through the stomach and upper small

## IP$_6$ with Inositol Greatly Enhances Natural Killer Cell Activity

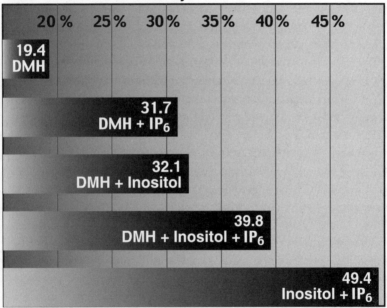

*In an experimental study to measure natural killer cell activity, the carcinogen dimethylhydrazine (DMH) was administered to four different in vivo groups. One group was also fed inositol hexaphosphate; another only inositol; another the combination of the two; and, the fourth group, inositol with inositol hexaphosphate but without DMH. The graph above depicts the natural killer cell activity of each group. The highest response is found in groups receiving the inositol plus inositol hexaphosphate formula.*

intestine into mucosal cells as inositol and the healing byproduct, InsP-1. It was also seen in many other organs as well.[13]

Many cancer drugs work by killing cells without discrimination—both cancer and normal cells. However, IP$_6$ has only moderate cell toxicity. Rather, IP$_6$ stops cancer cells from growing uncontrollably and normalizes them.

In 1997, Dr. Chuanshu Huang of the University of Minnesota found that IP$_6$'s antitumor effect occurs because it blocks enzyme PI-3 kinase activity. IP$_6$ redirects aberrant cells back to normal.[14] In their study, the researchers note that, on a biochemical level, IP$_6$ and its family of inositol phosphates are involved in a sequence of messenger cells, also called a signal transduction pathway. This pathway is activated by tumor promoters by way of an enzyme: phosphatidyl inositol-3 (PI-3) kinase. IP$_6$ has been found to have a structure very similar to a potent inhibitor of the PI-3 kinase enzyme. IP$_6$, thus, appears to work against, or inhibit, tumors by blocking the action of the enzyme. While cancer drugs could be developed to block PI-3 kinase as well, these same cancer drugs are inherently toxic.

IP$_6$ when combined with inositol also enhances cellular immunity by markedly stimulating natural killer cell activity. Natural killer cells play a central role in various aspects of the defense system, particularly against tumors. The work of Abul Baten, M.D., Ph.D., has demonstrated that IP$_6$ greatly enhances natural killer cell activity. He further correlated this increased activity with significant reduction of tumor incidence. These studies have been extended to human cell lines by Dr. Ivana Vucenik who found that human natural killer cell activity is enhanced after IP$_6$ treatment.

$Q$ *What cancers could be treated with IP$_6$ with inositol?*

$A$ Virtually all cancers will respond to IP$_6$ with inositol. We are constantly amazed by the reports coming in that show that it works with such a wide range of cancers.

In the pharmaceutical sciences, a commonly used measure to depict the efficacy of a drug or other substance is called the Inhibitory Concentration (IC). ICs come into play when there is a 50 percent inhibition of cell number—the IC$_{50}$. The concentrations required to achieve the IC$_{50}$ usually vary for different types of cancerous cells or cell lines.

Cancers of the blood-cell forming cells, including those implicated in leukemia and lymphoma, are highly sensitive to IP$_6$, while those of the skin and body cavity lining, connective tissues,

## Table 1

## EXPERIMENTAL STUDIES ON IP$_6$ AND CANCER

| Bodily Region—Specific Cancer Cell Line | Bodily Region—Specific Cancer Cell Line |
|---|---|
| Brain tumor—SR.B10A[1] | Lung cancer—HTB-119[3], RTE[8] |
| Mammary/Breast cancer— MCF-7[2], MDA-MB-231[2], MDA-MB-435[3] | Rodent lymphoma—YAC-1[3] |
| | Myeloid leukemia—HL-60[8] |
| Colon carcinoma—HT-29[4] | Prostate cancer—PC-3[9] |
| Erythroleukemia—K-562[5] | Skeletal muscle sarcoma —RD[10] |
| Fibroblast, immortalized— BALBc-3T3[6] | Skin cancer—JB6[11] |
| Liver cancer—Hep G2[7] | |

1: Kosaku Sakamoto, Gunma University, Japan [unpublished]. 2: Shamsuddin, A.M., et al. *Anticancer Research*, 1996; 16: 3287-3292. 3: Work in Dr. Shamsuddin's laboratory [unpublished]. 4: Sakamoto, K., et al. *Carcinogenesis*, 1993; 14; 1815-1819. 5: Shamsuddin, A.M., et al. *Cancer Letters*, 1992; 64: 195-202. Yang, G-Y & Shamsuddin, A.M. *Anticancer Research*, 1995; 15: 2479-2488. 6: Babich, H., et al. *Cancer Letters*, 1993; 73: 127-133. 7: Tantivejkul, J.M., et al. *Proceedings of American Association for Cancer Research*, 1998; 39: 314-315. 8: Arnold, J.T., et al. *Cancer Research*, 1995; 55: 537-543. 9: Shamsuddin, A.M., et al. *Journal of Nutrition*, 1995; 125: 725S-732S. 10: Vucenik, I., et al. *Proceedings of the American Association for Cancer Research*, 1997; 38: 96. 11: Huang, C. *Cancer Research*, 1997; 57: 2873-2878.

blood vessels, and lymph tissues appear to require higher concentrations of IP$_6$.

In Table 1 are results of experiments testing which cancer cell lines have been found to be inhibited significantly by IP$_6$. Based on extensive testing, it is likely that these cancers would be inhibited by IP$_6$ in living organisms as well.

Although some people and companies are marketing IP$_6$ as a dietary supplement and using the scientific work of Dr. Shamsuddin and others to add credibility to their formulas, it is important to further note that an anticancer cocktail—consisting of **inositol** (a member of the B complex family of vitamins) and **IP$_6$**—quite clearly possesses even greater (synergistic) effects.[15, 16] In other words, IP$_6$ given together with inositol (under the trade names **Cell Forté with IP$_6$ and Inositol**™ from Enzymatic Therapy or **Cellular Forté with IP$_6$ and Inositol**™ from PhytoPharmica) *works much better against cancer cells than either nutrient alone.* This combination's immune and anti-cancer effects are under a U.S. patent (5,082,833 issued January 21, 1992); only the two brands we have mentioned are proven safe, effective, and to possess the type of synergistic effects documented in scientific studies (see pages 88-89).

*Q* Is IP$_6$ with inositol helpful with hormone-related cancers?

*A* Some cancers, especially those of the male or female reproductive organs, are considered to be hormone-dependent. In these cases, the sex hormones, particularly estrogen and testosterone, are known to be critical to the formation and treatment of breast besides other cancers of the male and female reproductive tract.

"However, in order to respond to hormone treatment, the tumor must have a receptor for the hormone—sort of like a docking station," notes Dr. Shamsuddin in his own book, *IP$_6$: Nature's Revolutionary Cancer-Fighter* from Kensington Books. "For this reason, breast cancers are tested for the presence or absence of estrogen or progesterone receptors. Tumors of the

breast that are not hormone-dependent do not respond to hormonal treatments."

On the other hand, IP$_6$ is just as effective in inhibiting *both* hormonally dependent and non-dependent cell lines. IP$_6$ has also shown striking tumor inhibition of both testosterone-dependent and non-dependent cell lines. Because IP$_6$ is not dependent on hormone receptors, it has been shown to be effective in all types of men's and women's reproductive cancers.

$Q$ *Do people receive adequate IP$_6$ from dietary sources?*

$A$ People may consume foods rich in IP$_6$ such as soybeans and cereals. The amount they would have to consume to approximate the amount used in the studies, however, would be pounds daily and obviously impractical.

Capsules of the patented IP$_6$ with inositol complex, to augment the diet, are safe and have solid evidence supporting their use without risk.

$Q$ *Can other foods enhance the powers of IP$_6$?*

$A$ IP$_6$ may be synergistic with green tea, according to a 1997 study in *Carcinogenesis*.[17]

$Q$ *Since IP$_6$ is a form of phytic acid, won't it leach minerals from the body?*

$A$ Many studies have been done on levels of minerals after ingesting IP$_6$ supplements. All studies show levels remain unchanged or are normalized. Indeed, this concern is one of the great myths surrounding IP$_6$ with inositol. If anything, IP$_6$ with inositol is beneficial in normalizing the body's mineral balances (as mentioned on page 80).

# ANSWERS TO QUESTIONS ABOUT IP$_6$ WITH INOSITOL AND ITS USE IN CANCER TREATMENT

IP$_6$ WITH INOSITOL, the patented anticancer cocktail found in **Cell Forté with IP$_6$ and Inositol**™ from Enzymatic Therapy and **Cellular Forte with IP$_6$ and Inositol**™ from PhytoPharmica, is causing a huge stir throughout America, and the residue of this excitement has begun to reach us in an increasingly enthusiastic, yet ironically saddening, wave of letters.

These replies are not meant to diagnose or treat any existing condition. Your individual needs may be different than the situations described in these letters, so we recommend that you work with your physician or qualified health professional.

Our purpose, however, in presenting these letters from actual cancer survivors is to instruct persons with cancer and related health issues on the best way to derive maximum anti-cancer benefits from IP$_6$ with inositol. We have consulted with Dr. Abulkalam M. Shamsuddin, M.D., Ph.D., of the University of Maryland Medical School, in preparing answers to your questions. Dr. Shamsuddin is the world's leading expert on IP$_6$ with inositol.

We have eliminated virtually all names and addresses from these letters to protect people's privacy.

## HOW TO OBTAIN THE ONLY AUTHENTIC, SCIENTIFICALLY VALIDATED FORM OF IP$_6$ WITH INOSITOL

Please be aware that in using IP$_6$ with inositol there is only one brand that has our endorsement and that of Dr. Shamsuddin—and that is the actual substance studied experimentally and that is being studied in preliminary clinical trials. That brand is **Cell Forté with IP$_6$ and Inositol**™ from Enzymatic Therapy or **Cellular Forte with IP$_6$ and Inositol**™ from PhytoPharmica.

To find a health food store in your area carrying **Cell Forté with IP$_6$ and Inositol**, contact Enzymatic Therapy at 1-800 783-2286, write them at 525 Challenger Drive; Green Bay, WI 54311 or visit their web site at www.enzy.com.

To find a pharmacy or health professional carrying **Cellular Forte with IP$_6$ and Inositol**™ from PhytoPharmica, contact PhytoPharmica at 1-(800) 553-2370 (health professionals) or 1-800-376-7889 (consumers); 825 Challenger Drive; Green Bay, WI 54311; website: www.PhytoPharmica.com.

# CANCER LETTERS

Please note that in cases where several letters were received on the same topic, we have endeavored to present the letters in a group and to answer them all with one reply. These letters have been edited for accuracy and brevity.

## WOMEN'S REPRODUCTIVE CANCERS AND TUMORS (OVARIAN, UTERINE, BREAST)

### Ovarian Cancer

DEAR DR. COLES: *I was diagnosed with Stage IIIC ovarian cancer in 1992. In May 1997, I had a small tumor removed from a round ligament with no cancer showing outside the tumor. I had four rounds of Carboplatin that did not work. I entered a clinical trial for Interleukin 12 given interperitoneally. I have had five CT Scans in the past year, and none have revealed anything. The latest was in early June 1998. My CA 125 continues to rise and is now 895. I began taking tamoxifen in early June and also am taking 20 drops 3 times daily of Ewe tree tea. Today, I began taking Cell Forté after reading that it has anti-tumor properties. Have you had any other cases such as mine with results in lowering the CA 125? Sincerely, S.A.*

DEAR DR. COLES: *I want to send you a note of appreciation. It is very difficult to get accurate information on "alternative" modalities in the treatment of cancer, and then I read of your research into IP$_6$ with inositol in **The Doctors' Prescription for Healthy Living**. I had a hysterectomy for ovarian cancer, isolated to one ovary. I have had blood work tests (alphafetoprotein and CA 125) to check whether the cancer has come back, but understand their limitations. Also, a dear friend of mine was recently diagnosed with aggressive breast cancer. We are going to try treatments other than chemotherapy.*

*If you can refer me to other information, etc., I would appreciate it. We both eat mostly vegetarian and are highly knowledgeable about herbs and other so-called "alternative" treatments.*

*Again, thank you for your service to people.*
*Sincerely, T.L.*

**REPLY (TO BOTH):** Although not studied specifically on ovarian cancer cell lines, IP$_6$ with inositol has been studied for its ability to suppress and block other female reproductive cancers. As it has been shown to block breast cancer cell reproduction, there is a likelihood that it will help with ovarian cancer. We also have anecdotal evidence. One patient from Sarasota, FL, with ovarian cancer reported that her CA-125 "has not been rising at the level that she and her physician were expecting..." Her physician "was very impressed with IP$_6$ with inositol." For this reason and because of its complete safety record and immune-support qualities, we strongly urge women with ovarian cancer to consider use of IP$_6$ with inositol. We urge you to work with your doctor and to accept the best of both worlds, as both mainstream and alternative medicine have a great deal to offer.

### Fibroid Tumors

DEAR DR. COLES: *I found a reference to you in a health journal and felt you might be able to help me in some way. I have recently discovered that I have one grapefruit sized and three smaller fibroid tumors and am now on a*

*path of inquiry as to what I might do besides: (a) nothing; (b) wait until menopause for them to go away; or (c) having a hysterectomy.*

*I am 47 years old and otherwise very healthy. But I am 110 pounds, and I can feel these fibroids. I would like to gather as much information about the cause as I can, so that I can eliminate these growths. Any information or help you can offer will be greatly appreciated.*

*Thanks for you time, S.F.*

DEAR DR. COLES: *I read about IP$_6$ with inositol in the* **Doctors' Prescription for Healthy Living.** *Have there been any experimental studies regarding uterine fibroid tumors? Please send any information regarding the shrinkage of U.F. tumors with or without IP$_6$ with inositol. Thanking you in advance, L.J.*

**REPLY (TO BOTH):** IP$_6$ has been shown to normalize increased cell proliferation that is seen both in benign and malignant tumors. Although data on fibroids are not at hand, one male patient with benign prostatic hyperplasia, a condition akin to a fibroid in a female, has reported alleviation of his symptoms. Since IP$_6$ with inositol does not kill cancer cells, do not expect to see a dramatic reduction in tumor size, particularly that of fibroids, anytime soon. However, over a three to four month period, using eight capsules daily, you may see some change, especially if you work with your health professional to take advantage of the latest technologies in treating uterine fiberoids. At the very least, your fibroids should not grow as rapidly.

Also, be sure to reduce your exposure to endocrine disrupting chemicals, such as dioxin, that may play a role in the proliferation of reproductive abnormalities in women. Did you know that every time you use a bleached (white) coffee filter, paper towel, tampon, or other bleached paper product you are being exposed to dioxin? The solution is to seek safe and healthy products. Seventh Generation produces dioxin-free paper products. Be sure to pick up a copy of *The Safe Shopper's Bible* (Macmillan 1995) from your local book seller or health food store, and purchase safer products for

your home from companies such as Seventh Generation which is one of the few brands of household cleaning products to completely eliminate the dioxin problem.

## Breast Cancer

We have grouped together the letters on breast cancer and then have answered them all at the end of this section.

DEAR DR. COLES: *Hello! I just was diagnosed with breast cancer on Monday, found your article on Tuesday, and bought IP$_6$ with inositol (Cell Forté with IP$_6$) on Wednesday!!! I can't find anyone to supervise my use of it, because no one knows about it. I'm looking for Dr. Shamsuddin's book, too. I would be willing to be a human subject if more research is being done. How can I reach you to talk directly? How can I reach Dr. Shamsuddin? Thanks for all assistance. I am excited about this possibility! G.B.*

DEAR DR. COLES: *I was recently contacted by someone who wishes to try IP$_6$ with inositol and was hoping you could help. The woman's name is C.R., and she is 34 years of age. She has just been diagnosed with bilateral breast cancer and has had no conventional treatment to date. I was hoping you or one of your colleagues would be willing to assist C.R. in her dosage requirements. We decided to contact you after reading an intriguing article concerning IP$_6$ with inositol in Volume 2, Number 4 of **The Doctors' Prescription For Healthy Living**. Please contact us...*
*Sincerely, PAS*

DEAR DR. COLES: *I'm a 50 year old women and had a breast biopsy last March. The lump turned out to be cancerous and was removed. Tissue around the lump was clean and so were the lymph nodes they removed. The doctor I am working with put me on tamoxifen, and I have been on it since March. It is making me very sick; I have stomach problems and am now bleeding from the rectum. I take stool softener and laxatives all day long to keep my stool soft. I don't like this at all. My periods are extremely heavy and cramps are severe. I feel tired and unwell all the time.*

*I am writing you to find out about IP$_6$ with inositol and the results of the testing you have done on it. I have read **The Doctors' Prescription for Healthy Living** newsletter with regard to IP$_6$ with inositol and would like more extensive information about it. I totally believe in natural medicine and am very uncomfortable taking this drug that I'm on. I will be looking forward to more thorough information with regard to IP$_6$ with inositol from you.*

*Thank you very much, G.P.*

DEAR DR. COLES: *I recently read a newsletter about your research on IP$_6$ with inositol and would like to know whether you have advanced in your research. My wife is fighting breast cancer, and we wonder if you could help us. Please E-mail back any information that might help! Thank you and Merry Christmas, G.M.*

**REPLY (TO ALL):** IP$_6$ with inositol has been studied experimentally for its ability to both prevent and treat breast cancer. The studies have been extremely positive. In an experimental study, published in 1993 in *Cancer Letters*, breast tumors were reduced 40 percent.[18] At least six other studies have confirmed these excellent results.[19, 20, 21, 22, 23, 23]

We also have anecdotal evidence. In one case, according to Maryland pharmacist and nutrition expert Dr. Irv Rosenberg, a woman with breast cancer that had spread to virtually every bone in her body with lesions in her sacrum has stabilized completely since using high doses of IP$_6$ with inositol and has had no further increase in lesions. In this case, the IP$_6$ with inositol formula is at the very least prolonging survival. In fact, Dr. Rosenberg now frequently recommends IP$_6$ with inositol to breast cancer patients.

University of California researcher Edward Harris reports that his wife, diagnosed with metastatic breast cancer, has seen tremendously positive blood changes since starting on IP$_6$ with inositol. "She was on chemotherapy, and it took her platelet count down to 50,000. Plus, she experienced a blood infection and was hospitalized for 14 days. Her hematochrit was down to 24, her hemoglobin down to 8, and white blood cells at 9. Since she added IP$_6$ with inositol,

her hematochrit has gone up to 32, her hemoglobin has climbed up to 11, and her white blood cells are at 9—all within the normal range. I saw a striking difference."

This latest report comes to us from a woman in the Midwest, Susan D. Once diagnosed with stage III hormonally-dependent breast cancer, her oncologist basically told her she was as good as dead.

"He destroyed her and she wasn't going to put up with someone saying she would be dead in two years and that it would be a slow painful disease process," adds her husband. "He recommend radical mastectomy, six months of chemotherapy, radiation and a bone marrow transplant." She went through chemotherapy for several months, but it was extremely debilitating, and her laboratory tests were extremely negative.

Once she began taking IP-6 with inositol, "all of her markers started going great guns. She feels healthier than ever before. Her immune system has picked up. Her health feels good." As of press time, Susan continues to enjoy superb health.

We believe that all women should be taking $IP_6$ with inositol daily if for no other reason than to reduce their risk of breast cancer or its recurrence. Take ten to fifteen capsules daily of **Cell Forté with $IP_6$ and Inositol** from Enzymatic Therapy or **Cellular Forté with $IP_6$ and Inositol** from PhytoPharmica in two to three divided doses for an existing cancer and, possibly, up to 16 to 32 capsules daily depending on the severity and extent of disease. (See pages 88-89 for information on obtaining the recommended formulas.) Be sure to work with your health professional.

Besides $IP_6$ with inositol, a high potency soy extract and lots of tofu and soy-based foods would be helpful. We recommend **Soy Extract** from Enzymatic Therapy or PhytoPharmica because it is an all-natural soy extract (in gel capsules) with the highest potency available and with the precise ratio of genistein to daidzen isoflavones as found in nature, and the product is manufactured from non-genetically engineered soy beans. Be sure to use **Remifemin**™, a non-hormonal black cohosh extract that has been shown to enhance the efficacy of tamoxifen.

Also, read *The Breast Cancer Prevention Program* (Macmillan 1998) by Samuel S. Epstein, M.D. and David Steinman to learn about what you can do to prevent breast cancer from reoccurring.

### Ductal Carcinoma of the Breast

DEAR DR. COLES: *I am a cancer survivor. I had ductal carcinoma in situ (DCIS) of the right breast that was contained and did not involve the lymph nodes. I read in* **The Doctors' Prescription for Healthy Living** *that Cell Forté with IP$_6$ is important for anyone interested in cancer prevention.*

*Where can I purchase this product? Who is the manufacturer?*

*I would like to request the references you mentioned in the article entitled "Can IP$_6$ be used During Cancer Treatment?"*

*I had a total right mastectomy in September 1997. In June 1998, I had a TRAM Flap Breast Reconstruction. I am almost whole again and want to stay cancer free.*

*My regular doctors don't believe nutritional supplements can really help anyone.*

*Thank you for your help, S.S.*

**REPLY:** IP$_6$ with inositol is a fantastic insurance policy for women who have been diagnosed with DCIS. Most women with such DCIS cancers never suffer from full-blown breast cancer, as their "cancer" stays contained to a limited area. But because in a small number of cases such cancers may spread, doctors are often aggressive in their treatment and their patients mostly compliant, choosing to perform lumpectomies or even full mastectomies. Often, this strategy has been criticized as being too aggressive. IP$_6$ with inositol is the perfect supplement for you. It will prove to be an important insurance policy for women who have been diagnosed with DCIS. IP$_6$ with inositol will help to insure that such cancers do not spread. It would be a smart thing to begin on IP$_6$ with inositol, taking a medium dosage of six to eight capsules daily of **Cell Forté with IP$_6$ and Inositol** from Enzymatic Therapy or **Cellular Forté with IP$_6$ and Inositol** from PhytoPharmica (see pages 88-89 for information on how to obtain

these products). Combine this with Soy Extract and Remifemin from Enzymatic Therapy or PhytoPharmica (see page 89 for additional information on how to obtain both formulas).

## MEN'S REPRODUCTIVE CANCERS

### Testicular Cancer

DEAR DR. COLES: *I read your article re: IP$_6$ in **The Doctors' Prescription for Healthy Living** (Vol. 2, No. 5) and would like to know if you can provide me with any other information on this product. My husband is currently undergoing BEP treatment for Stage III testicular cancer (in his abdominal lymph nodes and quite extensively in his lungs). He handled the first five-day treatment well and is breathing better.*

*We are willing to supplement his treatments with anything that is worthwhile to use. A health-food store employee suggested ImmuDyne's MacroForce® Plus C and another suggested the IP$_6$ with inositol.*

*Do you have an opinion on which would benefit my husband more and why?*

*There are so many products claiming to help, and we want to ensure we are doing the best we can to beat this cancer without purchasing unnecessary products.*

*We would appreciate all the information you can supply.*

*Thank you very much, KDM*

REPLY: IP$_6$ with inositol has not yet been studied for its effects on testicular cancer, but it has been studied with extremely positive results experimentally on lung and prostate cancer (another reproductive cancer). What's more, IP$_6$ with inositol has been shown to be effective in a variety of cancer cell lines both from male and female reproductive organs. As IP$_6$ with inositol has no drug interactions or other toxicities or complications and it can significantly enhance the immune system's production of natural killer cells, we believe that IP$_6$ with inositol could very well benefit your husband both in terms of "re-educating" his body's cancerous cells and in supporting his body's immune function while he undergoes his standard cancer

treatment. The standard dosage for cancer treatment is 10 to 16 capsules of **Cell Forté with IP$_6$ and Inositol** from Enzymatic Therapy or **Cellular Forté with IP$_6$ and Inositol** from PhytoPharmica (see also Resources, pages 88-89 for additional ordering information).

At this time IP$_6$ with inositol has not been studied with ImmuDyne's MacroForce® Plus C, but we suspect that the combination would be extremely powerful. That is because MacroForce Plus C provides the body with a patented form of beta-1,3-D-glucan that has been conclusively shown to increase the immune system's macrophage production. Macrophages are immune cells that are the body's first line of defense against bacterial, viral, and fungal pathogens as well as diseased cells. The usual dosage of beta-1,3-D-glucan during cancer treatment is two to five 7.5 milligram capsules daily.

Together, we believe that MacroForce Plus C and IP$_6$ with inositol would be most beneficial. It is not a matter of which is better. IP$_6$ with inositol stimulates natural killer cells and has other enzymatic effects that are beneficial in reordering cancer cells back to normalcy. The effect of beta-1,3-D-glucan is to stimulate macrophages, the result being a marked increase of overall immune response. A powerful combination is created when both products are used in conjunction and should be helpful to many of our readers with cancer.

Each type of these cells—rare natural killer cells and the more numerous macrophages—are critical, yet different components of immunity. Natural killer cells are adept at destroying cancer cells, while macrophages are the body's first line of immune defense. Without the active, alert vigilance by the macrophages the body becomes more susceptible to opportunistic infection (an especially important consideration for persons undergoing chemotherapy or radiation). Thus, both substances are complementary rather than overlapping in function.

But there are two more important facts people should know: First, beta-1,3-D-glucan helps to maintain strong immune function in persons undergoing chemotherapy or radiation. Second, beta-1,3-D-glucan works best in cases of highly malignant tumors that

are not able to be effectively recognized by the immune cells. In a sense, beta-1,3-D-glucan helps immune cells target these tumors for destruction they previously could not. These are also the tumors with the poorest prognosis.

Finally it's important to remember not all beta glucan is created equally. Crude, non-purified forms of beta glucan are easy and cheap to produce; however, the tough questions still remain: How pure is the compound you're using and will it cause allergic reactions in those persons sensitive to yeast? And does your brand consist of the most potent molecular configuration: beta-1,3-D-glucan. What's more, to expect the results that were found in scientific studies, you need to use the same formula that was used in these studies. Over the last 12 years, ImmuDyne has sponsored numerous studies on their own beta-glucan compound, the result of which is their patented MacroForce product. (For order information, see page 89.)

### Prostate Cancer

DEAR DR. COLES: *I recently read your article on IP$_6$ in* **The Doctors' Prescription for Healthy Living.** *I also just finished reading Dr. Shamsuddin's research findings published in his book,* **IP$_6$: Nature's Revolutionary Cancer Fighter.** *I also spoke with Dr. Shamsuddin by telephone. It is my understanding that IP$_6$ causes cancer cells to return to normal. I also gleaned, from an article published in* **Let's Live,** *that there have been some human studies that indicate it works in the case of prostate cancer and adenocarcinoma. Would you care to comment on the latter? I am sharing your article with as many people as I can find who have cancer. I, like you, believe this discovery is going to be BIG. I would greatly appreciate your comments on IP$_6$ and NK cell activity, returning cancer cells to normal and its use for adenocarcinoma. (I myself had ovarian adenocarcinoma and surgery for it last January. Eight rounds of chemotherapy followed. I am taking, as per Dr. Shamsuddin's directions, eight capsules twice daily on an empty stomach.) Thank you for your time and consideration. Y.P.S.*

**REPLY:** In 1995, Dr. Shamsuddin and a colleague investigated the effects of inositol hexaphosphate ($IP_6$) on growth inhibition and differentiation of human prostate cancer cells *in vitro* (in the test tube).[25] When cells begin to differentiate again, it is a sign of a return to normal. A significant dose- and time-dependent growth inhibition was observed. A marker for prostatic cell differentiation —prostate acid phosphatase—was significantly increased after forty-eight hours of treatment. The compound "strongly inhibits growth and induces differentiation in human prostate cancer cells," said the researchers.

With regard to your question concerning the effect of $IP_6$ on natural killer cell activity, these are immune cells produced in the bone marrow and matured in the thymus gland, explains Ken Babal, C.N. "Armed with an estimated 100 different biochemical poisons for killing foreign proteins, NK cells can recognize and quickly destroy virus and cancer cells," says Babal. Dr. Shamsuddin and other investigators have shown that the combination of $IP_6$ with inositol has positive benefits on NK cell activation. Noting that in their studies $IP_6$ inhibited experimental colon carcinogenesis, they wondered whether this effect could be due to natural killer cells, since they are involved in tumor cell destruction. They investigated the effect of $IP_6$ on experimental NK cell activity.[26] They found 1,2-Dimethylhydrazine (DMH), a colon carcinogen, depresses NK activity; but that treatment with $IP_6$ enhanced NK activity and reversed DMH-induced depressed NK activity. $IP_6$ also enhanced the potency of NK cells by increasing their cytotoxicity in a dose-dependent manner. "Our data suggest yet another important role of inositol phosphates in the regulation of cellular activity," noted the authors.

## CHILDHOOD CANCERS

We have grouped together these letters on brain cancer and then answered them all at the end.

## Brain Cancer

DEAR DR. COLES: *Our 11-year old daughter has a brain tumor on her brain stem, cerebellum, and midbrain. It is diagnosed as an anaplastic, astrocytoma—Grade III. We just learned about IP$_6$ with inositol. Do you feel that this can shrink this tumor? She was first diagnosed in May 1997. She has had two surgeries, been on three kinds of chemotherapy, and had six weeks of radiation treatment. Please let us know ASAP. We thank you very much. K.S.M.*

DEAR DR. COLES: *I read your quote about a brain tumor regression with some credit going to the use of IP$_6$ with inositol. I have a 12-year old daughter who had a brain tumor surgically removed one month ago, and she is about to begin radiation treatments. We have already begun her on a serious regimen of supplements, and I have read much about IP$_6$ with inositol. I am desperately looking for someone who can help me sort out the BEST CHANCE supplement/cancer fighter for my daughter as we begin this long battle. Everyone has their own opinions, and the more I ask, the more confused I get. I don't know if you are the right person with the right background that I'm looking for, but I'm obviously doing everything I possibly can to save my child. If you can shed any light on this subject, I'd appreciate it greatly. I'm particularly interested in IP$_6$ with inositol. Thank you for taking time to help us. S.F.*

**REPLY (TO BOTH):** Our answer to both queries is an emphatic *yes*. May God be with you and your children! An astrocytoma is also called a glial cell tumor since these arise from astrocytes, which are glial cells. Cancer cells derived from glial tumors have been found to be inhibited by IP$_6$ with inositol experimentally. We know of at least two cases where glioblastomas have been observed to become smaller. So, please, have your child start taking 12 to 15 capsules daily as part of his or her treatment program. There's more. In this case we now have much clinical evidence, anecdotal though it may be, that IP$_6$ with inositol does help. Jeanne M. Wallace, Ph.D., C.N.C., reports that in her work with brain tumor patients she utilizes a comprehensive nutritional and

botanical protocol as a complement to conventional therapies (cautiously and selectively chosen). "My approach is to utilize integrative support to impact the cancer process from many angles: inflammatory cascade, immune function, angiogenesis, invasion, cell-cell communication, differentiation, and apoptosis," she says. An article summarizing her work appeared in the March 1999 issue of the *International Journal of Integrative Medicine* (formerly the *American Journal of Natural Medicine*). Here is a summary of her current brain tumor clients who are taking IP$_6$ with inositol as part of their protocol:

| Client | Diagnosis | Date of Diagnosis | Status* | Treatments** |
|--------|-----------|-------------------|---------|--------------|
| A.R. | GBM IV | 3/95 | excellent | S, RT, GK, CH |
| D.K. | GBM IV | 3/97 | excellent | S(2), RT, CH |
| C.C. | GBM IV | 10/97 | excellent | S, RT, GK |
| D.Cl. | GBM IV | 9/98 | excellent | S, RT |
| B.R. | GBM IV | 3/98 | stable | S, RT, CH, Cantron |
| R.P. | GBM IV | 7/98 | excellent | S, RT |
| D.Cr. | GBM IV | 8/98 | stable? (inoperable) | RT |
| R.L. | AA II/III | 6/91 | stable | S(2), RT |
| E.T. | AA III | 5/98 | stable | S, RT, BDY, CH |

*Status, as of 12/1/98, is reported as Excellent when history includes regression of the tumor as demonstrated by MRI; reported as Stable when MRIs to date show no progression of the tumor.

** Treatment Key: S= surgery, RT=radiation therapy, CH=chemotherapy, BDY=bradytherapy, GK=gamma knife.

These clients are taking an average of four to six grams of inositol hexaphosphate with inositol per day (10-15 capsules of either the PhytoPharmica Cellular Forté with IP$_6$ and Inositol or Enzymatic Therapy Cell Forté with IP$_6$ and Inositol product). This dose is taken in 3 divided doses, on an empty stomach (contents of the capsule are emptied into 2-4 ounces of purified drinking water). IP$_6$ with inositol was begun in March 1998 for the first 3 clients, and shortly after diagnosis for those clients more recently diagnosed, reports Dr. Wallace.

"Some of the additional supplements utilized by my clients (protocol is tailored for each patient) include: a multiple vitamin/mineral

(without iron); high-dose bromelain, maitake D-fraction, astragalus, Siberian ginseng, alkylglycerols, and an omega-3 fatty acid supplement," says Dr. Wallace.

Contact: Jeanne M. Wallace, PhD, CNC
Clinical Nutrition Consultant
NUTRITIONAL SOLUTIONS
3300 Portola Drive, Suite 6
Santa Cruz, CA 95062-5159
Phone/Fax: (831) 464-9510
E-mail: jeanbean@cruzio.com

## OTHER CANCERS

### Hodgkin's Disease

DEAR DR. COLES: *My name is J.S., and I have been diagnosed with Hodgkin's disease. I was first diagnosed in April of '96 and since then I have relapsed three times, possibly four. The first time I had the regular chemo/radiation therapy dose that they give to lots of patients. After the cancer came back, I had an autologous stem cell transplant. This did not work either, and they surgically removed another tumor and radiated the area. I chose this option because I wanted to continue to go to college and not quit for another semester. The doctors wanted me to possibly do another stem cell transplant, since I collected enough cells the first time to have two to three transplants. But my theory is, if it didn't work the first time, why bother doing it again when the odds go down for a cure with a second transplant? Well, I am changing my diet to vegetarian. I have started Essiac tea and pau d'arco tea, and I have many herbs with anti-cancer properties. I am trying to follow the diet by Anne Frahm in her book A Cancer Battle Plan, but there is a possibility that this hasn't worked either. My latest CT scan was in mid May, and it showed subtle changes in my sternum area, where I have previously had tumors. My doctor said it was probably too early to worry about doing any conventional treatment yet, and I decided to wait until August to have another scan. But I would like to begin something now, instead of relying only on the nutritional changes I've already made and herbs.*

*I was wondering if IP$_6$ with inositol would be able to help me, and if so, how to obtain it, and how much it costs. If I find out that I have the cancer again, I would be willing to participate in any clinical trials that are offered, as I don't want to do a stem cell transplant unless it is my last option. I am looking for something with minimal side effects; I have lost my hair twice already, and I don't want to have to go through that again. In spite of all the chemo that I have had, I still believe that I may be able to have children, but I think if I have another transplant I will become sterile.*

*Another option I have is to search on the bone marrow registry, because my only sister is not a match. But I am only 21 years old, and I have not had a normal year at college. I am trying to find a way to cure this horrible disease without harming the good cells in my immune system. I now have done my reading and realize exactly how debilitating chemotherapy is on the body.*

*I hope to hear from you soon.*

*If you could give me any references, I would appreciate it.*

*Thank you, J.S.*

**REPLY:** Experimentally, lymphoma cells lines have been found to respond to IP$_6$. Although Hodgkin's disease is also a lymphoma, it was not tested per se. However, there are anecdotal reports that both Hodgkin's disease and non-Hodgkin's lymphoma have responded well, and these reports, limited as they are, provide the basis for real hope. As with other active cancers, our recommended dosage is 10 to 15 capsules of **Cell Forté with IP$_6$ and Inositol** or **Cellular Forté with IP$_6$ and Inositol** (see pages 88-89 for information on how to obtain these formulas). We recommend that you begin using IP$_6$ with inositol immediately to stem the tide on any latent cancer cells and to re-educate them back to normalcy.

### Non-Hodgkin's Lymphoma

DEAR DR. COLES: *I just finished reading your story on the IP$_6$ with inositol in the **Doctors' Prescription for Healthy Living**. It was very informative and interesting. I am a survivor of non-Hodgkin's lymphoma for eight years now. I was pregnant at the time with my first baby, and suc-*

*cessfully treated. My son was born absolutely perfect; he is a strong, athletic eight-year old. I feel very fortunate. I am always looking for ways to prevent cancer and keep myself healthy. I eat well, take supplements, and read lots of material on natural health care. When do you expect IP$_6$ with inositol will be on the market in health food stores, and will it be pricey? I would appreciate more information on this supplement. I hope my story is inspiring for you and that maybe my success story can be passed on to other patients. Thank you for the information.*

*Hope to hear from you soon, S.*

**REPLY:** Thank you for your inspiring story. Yes, IP$_6$ with inositol is available now. The only product in health food stores that contains the actual substance that has been studied is **Cell Forté with IP$_6$ and Inositol** from Enzymatic Therapy (see page 88 for information on how to obtain this product).

Be sure to also avoid use of permanent hair dyes and pesticide exposures. Both have been linked to increased risk of non-Hodgkin's lymphoma. You may want to pick up a copy of *The Safe Shopper's Bible* (Macmillan 1995) and *The Breast Cancer Prevention Program* (Macmillan 1998) from your local book seller or health food store and subscribe to *The Doctors' Prescription for Healthy Living* for additional information on preventing cancer and keeping your family safe and healthy (see page 90).

## Lymphoma

DEAR DR. COLES: *I have been going through an ongoing tussle with lymphoma, primarily with a tumor that likes to wrap around my spine and make it difficult for me to walk. I've been through chemo and radiation, which were necessary, but I'm trying natural methods at present to keep it at bay. A friend told me about IP$_6$ with inositol and said you wrote an article on it. Could you tell me where I might find more information and the product itself?*

*Thanks, L.L.*

**REPLY:** You're lucky to have such friends. Yes, IP$_6$ with inositol could prove most useful. In fact, lymphomas are a type of cancer against which IP$_6$ with inositol has proven quite effective experimentally. In one clinical case, a patient with stage IV lymphoma and 20 percent chance of remission began using IP$_6$ with inositol and did, in fact, experience a remission. We know of several other lymphoma patients who have done well, based on the work of Maryland pharmacist Dr. Irv Rosenberg.

### Colon/Rectal Cancer

We have grouped together these letters on colon/rectal cancer and then answered them all at the end.

DEAR DR. COLES: *My name is C.M., and I just received **The Doctors' Prescription for Healthy Living**. I was diagnosed with colon cancer in October '96 and, when a CAT Scan was done, it was discovered that the cancer had metastasized to my liver. Surgery was done, and the tumor was removed from my colon. But nothing could be done for my liver. I was told I had anywhere from two to fifteen months to live. After much reading and talking to people with various types of medical backgrounds, I opted to go for the alternative method to try and boost my immune system and not do chemo. I have been on this program for 1$^1$/2 years.*

*I am very interested in IP$_6$ with inositol but am at a loss where to purchase it. It says in the article to purchase the Enzymatic Therapy brand. Do you have a source who sells this brand? I live in Phoenix, Arizona.*

*Also, my oncologist has been very narrow minded about anything other than surgery, radiation, and chemotherapy. If I try to talk to him about anything other than the above, he doesn't want to talk about it. What kind of doctor should I see if I can get this product? It said in the article to work under the guidance of your attending physician. Would a naturopathic doctor be appropriate?*

*I would appreciate any information you can give me.*
*Thank you in advance for any help you can give me. C.M.*

The Cancer Letters

DEAR DR. COLES: *My name is R.T., and I am home recuperating from colon/rectal surgery after having been diagnosed with a tumor in my rectum. They also found additional lesions on my liver and have scheduled me for chemotherapy.*

*My wife found IP$_6$ with inositol at a local health store, and I have begun taking it as directed. I am wondering if I should consider mega-doses or are there other forms of treatment that are being experimented with involving IP$_6$ with inositol?*

*Any help or direction you can give me will be most appreciated.*
*Sincerely yours, R.T.*

DR. COLES: *Hello, my name is S.S., and I am interested in your article in* **The Doctors' Prescription for Healthy Living.** *Could you provide me with any statistics regarding colon cancer and IP$_6$ with inositol or the avenue on which I may obtain such information?*

*Additionally, I was interested if you knew of any beneficial aspects of IP$_6$ for Crohn's disease regarding cancer formation.*
*With sincere thanks, S.S.*

**REPLY (TO ALL):** We have encouraging news for people with colon cancer. Not only do we know that IP$_6$ with inositol works extremely well in reducing tumor incidence and treating colon cancer cells experimentally, we also have limited human evidence. One patient with Crohn's disease in Stockholm, Sweden, a relative of a physician, was reported to feel much better after he had been on IP$_6$ with inositol. Crohn's disease is known to increase the risk of cancer of the affected bowel. Thus, IP$_6$ with inositol is very likely to be beneficial in lowering that risk. Insofar as mega-doses, we are now getting reports of persons taking sixteen to thirty capsules daily who are receiving benefits, based on their subjective evaluation, and that of their doctor.

We are now seeing these results anecdotally, thanks to the life-saving work of one of the nation's most progressive doctors of pharmacy. "I'm seeing improvements with people that I attribute, in part, to their use of IP$_6$ with inositol," notes Maryland pharmacist and nutrition

consultant Dr. Irv Rosenberg. "My colon cancer patients are doing better than I would have expected when we add IP$_6$ with inositol to their protocol which may also include conventional therapies. I am impressed with IP$_6$ with inositol. The research is solid. Impressive. I recommend it to many cancer patients. In one case a colon cancer patient's metastasis disappeared from the liver. In another, case, her doctor said the metastasis was cut in half. The IP$_6$ with inositol seems to have hastened the results patients are receiving."

Six capsules daily would be a good prophylactic dose, and 10 to 15 capsules daily would be appropriate if a person has an active cancer, to be used with their physician's recommended treatment.

## Pancreatic Cancer

We have grouped together the letters on pancreatic cancer and answered them all at the end.

DEAR DR. COLES: *Just a few days after reading your article in* **The Doctors' Prescription for Healthy Living** *newsletter on IP$_6$ with inositol, we learned that my father has a tumor on his pancreas. It is at the head of the pancreas and has choked off his bile duct, causing jaundice. The jaundice has been fairly well relieved by the implantation of a stent from the pancreas to the intestine.*

*The biopsy showed no positive cells, although the surgeon says this does not necessarily mean there is no cancer present. However, in light of that, he has pulled back from his initial recommendation to an oncologist for chemotherapy and radiation treatment, and is now suggesting waiting to see what happens.*

*Do you have any sense of whether or not IP$_6$ with inositol, together with a regimen to strengthen my father's immune system, might be of benefit in this case?*

*Also, can you recommend a good general program to aid the restoration of his immune system? Is IP$_6$ with inositol, in the form you mention, widely available? My father lives in New Hampshire.*

*My father is in his mid-eighties, but is vital and alert. He has adult onset diabetes that has been treated with tolinase for the past 12 years or so. (I have heard that diabetes medications could affect the pancreas.) He*

*has also had some problem with low blood pressure. Many thanks for whatever you might be able to recommend.*
*F.S.*

DEAR: DR. COLES: *My brother just purchased a bottle of IP$_6$ with inositol from the health store. He became aware of the formula through your articles. He was diagnosed with pancreatic cancer in December 1997. The cancer is also in the vessels of the pancreas which made it inoperable. He was given radiation and chemo together, and after treatment has been wearing the chemo belt with FU5 pumped into him constantly. He has done well, with his energy level high. The cancer has not interfered with his physical ability to do things. The tumor shrank at last scan one centimeter, and he is due for another picture July 6th. He is 44 years old and in excellent health otherwise, and the cancer, to date, has not spread. He started taking the IP$_6$ with inositol today. Will this vitamin help the cancer to shrink in his pancreas? Do you have any other recommendations when taking this vitamin? Any help you can give him regarding this treatment will be helpful.*
*K.K.*

**REPLY (TO BOTH):** IP$_6$ with inositol is likely to help alleviate the complications of diabetes mellitus, as the intracellular levels of inositol and inositol phosphates are low in diabetes, contributing to the complications. We have direct anecdotal evidence regarding pancreatic cancer treatment. A physician with pancreatic cancer underwent surgery for the removal of the head of his pancreas and, at the same time, began taking IP$_6$ with inositol. He has had no reoccurrence for six months, which is a very promising result for this type of difficult-to-treat cancer. We believe that IP$_6$ with inositol may have a broad-spectrum effect on many cancers. Although we cannot offer you more than this quite limited evidence, we do offer encouragement for this reason: IP$_6$ with inositol has no known complications; it is safe to use and we now have anecdotal evidence, limited though it might be—it is worth using based on the safety ratio and the fact that it seems to work with a wide range of cancers.

## Liver Cancer

DEAR DR. COLES: *My name is M.C. I have read your article on IP$_6$ with inositol and I have many questions. My uncle J.B. was diagnosed with liver cancer on May 1. The attending physician had told him there was no hope; they later found a doctor at Vanderbilt Medical Center in Nashville, TN. The doctor planned to do a procedure called chemo embolization. In the process of running tests to prepare for this procedure, they found that the portal vein had been closed off completely by the tumor, leaving the hepatic artery as the only blood supply. The way they had planned to do this procedure, it would become closed off, making the procedure impossible to perform without J.B. dying. Since then, we have found your article, and we are hopeful there is yet something we can try. I need to know how we can go about getting this formula, and are there any side effects? Plus, he is having trouble with his blood being too thin as it is. The doctors had put him on vitamin K for ten days prior to the first attempt for the procedure. If you have any information we can use or any suggestions at all, we would be very grateful. My uncle still has his hopes very high that he is going to beat this, but all the while he is getting weaker. We would like to hear something as soon as possible.*

*Thank you, M.C.*

**REPLY:** Your uncle's blood is too thin because of extensive replacement of his healthy liver by cancer; healthy liver cells produce blood clotting factors. Experimentally, IP$_6$ has been found not only to reduce the growth of liver cancer cells in the test tube but to shrink pre-existing human liver cancer cells in xenotransplanted nude mice.

When you read about IP$_6$'s amazing anticancer properties, especially regarding liver cancer, we believe that you're going to say to yourself that *not* using this supplement is simply no longer an option.

Liver cancer, also called hepatocelluar carcinoma, is common throughout the world but particularly in China. Its occurrence is closely associated with the hepatitis B virus, cirrhosis of the liver caused by alcohol, excess iron, and other chemical and biological toxins. For example, persons who are exposed to the hepatitis virus, then the bio-

logical pathogen, aflatoxin, are more likely to contract liver cancer than persons not previously exposed to hepatitis. It is a deadly disease with death usually occurring less than six months after diagnosis. Americans have become more attuned to this tragic disease because of the tragic demise of baseball legend Mickey Mantle who contracted liver cancer after a lifetime spent battling alcohol, both during his days as a professional ball player for the New York Yankees and after.

Not surprisingly, Chinese medical scientists have been especially interested in a natural prophylactic agent that is effective against liver cancer. According to Dr. Shamsuddin in his important book from Kensington Publishing *IP$_6$: Nature's Revolutionary Cancer-Fighter*, in the summer of 1976 Dr. Zhenshu Zhang from Nanfang Hospital of the First PLA Medical College in Guangzhou, China, came to Maryland and visited Dr. Shamsuddin's laboratory.[27] The two doctors discussed the tragic implications of liver cancer worldwide, and particularly in China, and the lack of effective conventional treatment.

After hours of discussion and sensing Dr. Zhang's burgeoning enthusiasm over the powers of IP$_6$, the two agreed to a joint scientific investigation to determine whether IP$_6$ could be helpful to persons with this deadly cancer.

Their first cell line experiments took place in the test tube (*in vitro*). Taking human liver cancer cells, the scientists divided them into two groups. One was left untreated and the other treated with IP$_6$. The untreated cells proliferated rapidly. But the cells that were treated with IP$_6$ experienced tremendous difficulty in proliferating. What's more, as the researchers added more IP$_6$ to the cells, their growth became even more limited and, finally, terminal. That meant that the potential for inhibition of growth was truly dependent on the amount of IP$_6$ to which they were exposed. At the highest dosage, IP$_6$ was so effective that the growth of the liver cancer cells was completely halted.

The next test involved transplantation of human liver cancer cells via injection into a biological organism (*in vivo*). The results again were significant. If the transplant was done before the cells received IP$_6$, then solid tumors were more likely to occur. In fact, 71 percent of the total transplanted cell lines were able to reproduce and, there-

fore, proliferate. On the other hand, two days of pretreatment of the liver cancer cells with IP$_6$ completely inhibited tumor development. But what about treatment of pre-existing liver cancers? This information is critical to the millions of persons who will develop this deadly cancer during their lifetime. Once again, IP$_6$ proved its merit and proved to be a superb cancer killer. The doctors allowed the tumors to reach about eight to ten millimeters in diameter. This would be akin to a tumor the size of a basketball in humans, notes Dr. Shamsuddin. Tumor treatment with IP$_6$ ensued for twelve days without any interruption whatsoever. At the end of the treatment period, the tumors that were exposed to IP$_6$ weighed over three times less than those without the IP$_6$. In other words, on a weight-by-weight basis, the untreated tumors weighed about $3^1/_2$ times more.

The researchers then wanted to find out the minimum dose for liver cancer inhibition. They found that in cases of pre-existing tumors, even one treatment with IP$_6$ was enough to completely inhibit cancer cell proliferation.

The ability of IP$_6$ to cause regression of already-existing tumors left a deep impression on both scientists. Finally, there was true hope for a nontoxic natural treatment agent for persons with this deadly cancer.

For this reason alone and because of its safety, IP$_6$ with inositol would be excellent to use by anyone with liver cancer. But there is more. Anne was diagnosed with stage IV, highly advanced liver cancer in March 1995 and underwent surgery, but the cancer recurred in October 1996 and spread even further to her lungs and lower spine. On her physician's advice, Anne underwent chemotherapy and radiation, but eventually felt worn out and exhausted. "I just couldn't take any more chemo or radiation," she says. "I needed to do something. So I began taking the IP$_6$ with inositol from Enzymatic Therapy. I'm telling you, the difference it has made in my life is nothing short of miraculous. Whereas before, I could hardly move, now I am able to get up and get around. IP$_6$ with inositol gives me the energy I need. People don't think I have cancer. I now take five capsules four times a day. My lab results show that it is working. In fact, I had gotten one of my cancer

markers way down and foolishly stopped taking the $IP_6$ with inositol to save money. Afterward, my cancer markers quickly jumped up. Now I am back on my regimen, and my cancer markers have gone back down. The $IP_6$ with inositol has really kept me going. The doctors told me I had three months to live during the course of my illness. Well, thanks to $IP_6$ with inositol, I have long passed that benchmark."

In another case, C.C. was diagnosed with stage IV liver and colon cancer and given three weeks to live in April. His sister-in-law suggested that he take $IP_6$ with inositol, only five capsules a day instead of five capsules three times a day. He called his sister in July and told her that not only was he obviously alive but that the doctor said his immune system was one of the best functioning he had ever seen! Although he underwent chemotherapy, his doctor credits his remission in part to his use of $IP_6$ with inositol.

One last word of advice. Your doctor should work with your uncle to determine if any of his blood test parameters change, a precautionary statement that we would make for any patient on any medication who is considering using nutritional supplements.

### Bladder Cancer

DEAR DR. COLES: *I read your article on $IP_6$ with inositol; it was very interesting. Here at the university hospital I had some urine samples taken because I have been experiencing bladder pain for the last several months. Yesterday, the physician said that I might have bladder cancer. He is going to run some tests—an intravenous pyelogram, in which he will put a tube with a light in my bladder to see whether there are any tumors. For years I have eaten a good natural diet (vegetarian), exercised, and have lived a healthy lifestyle.*

*In fact, several years ago I obtained a Ph.D. in health promotion with a minor in nutrition. So sometimes, a person can do the best they can in living a healthy life but still get cancer.*

*I am not afraid of dying, but I do not want to give up without a fight. If you know of any good alternative health diets that I could follow to help me fight this bladder cancer problem, please E-mail, and please feel free to*

*offer any additional advice. Since I have spent a great deal on medical expenses, taking expensive food supplements are really out of the question. I really want to maintain my health with natural foods. Thank you.*
*Sincerely yours,*
*L.S., Ph.D., C.H.E.S.*

**REPLY:** Many cancers are due to carcinogens or cancer-causing agents that are found in our environment. While eating a healthy diet may be protective if the carcinogenic insult is only mild, the existence of other promotional factors and high carcinogenic doses can overwhelm the protective role of a healthy diet; hence supplements are needed. This is where IP$_6$ with inositol can be not only prophylactic but also therapeutic. The use of IP$_6$ with inositol in a preventive dosage of four to six capsules daily is recommended with an increase to 10 to 15 capsules if you do indeed have a cancer. And some persons, as mentioned earlier, are using up to 30 capsules daily. Also be sure to drink only filtered water and to consume anti-cancer beverages, particularly green tea and pau d'arco.

## Lung Cancer

DEAR DR. COLES: *I just read your article in* **The Doctors' Prescription for Healthy Living**. *It was very interesting. IP$_6$ with inositol might be something that could help my Mom. A quick overview: she had recent heart surgery (age 85) to replace a mitral valve and repair a tricuspid valve. She is now on Coumadin for life because her valve replacement was mechanical. Can IP$_6$ with inositol be taken with Coumadin?*

*When the heart surgeon was inside my mother's chest cavity, he found a lump deep in the upper left portion of her lung (she's not a smoker nor around one). Although he did not say he thought it was cancer, his body language and general demeanor were not positive—more preparatory for the worst—and he wants to bring in an oncologist at some time. We have yet for it to be biopsied, as she is still recovering from surgery. He said to give it another couple of months before we proceed with diagnosis. I would like her to begin the IP$_6$ with inositol as soon as possible if not contraindicated.*

*I would appreciate a response very much! Thank you for this and for being an MD who is tuned in to complementary medicine. You are so few and far between. Thank you.*
*C.D.*

**REPLY:** $IP_6$ is effective against lung cancer in experimental studies. And it is also important to mention that more and more people who do not smoke are coming down with lung cancer, we believe, in part because of industrial pollution and, perhaps, pollution in the home. Have your mother start taking 10 to 15 capsules of **Cell Forté with $IP_6$ and Inositol** or **Cellular Forté with $IP_6$ and Inositol** daily. Please read other reports that show that persons with lung cancers have experienced regressions, thanks to $IP_6$ with inositol. Also see pages 63-66 where we discuss the use of $IP_6$ with inositol and Coumadin.

## Melanoma

DEAR DR. COLES: *I understand you may know something about a fairly new supplement for cancer prevention and treatment. It is called $IP_6$ (inositol hexaphosphate) with inositol. Do you have any clinical or research data that suggests it helps people with melanoma? I have a friend in need of immediate input. Thanks for any information you may have. S.B.*

**REPLY:** Fortunately, $IP_6$ with inositol has been shown to experimentally inhibit skin cancer, based on research from the Hormel Institute, University of Minnesota, Austin. In this study, researchers investigated the influence of $IP_6$ on tumor promoter-induced cell transformation and signal transduction pathways that are considered to play a crucial role in tumor promotion.[28] $IP_6$ markedly blocked skin growth factor-induced phosphatidylinositol-3 (PI-3) kinase activity in a dose-dependent manner in skin cancer cells. We would therefore recommend its use in tandem with other therapies that your health professional recommends. Have your friend take 10 to 15 capsules daily in three divided doses.

## Myeodysplastic Syndrome

DEAR DR. COLES: *My husband is a 65-year-old autologous bone marrow transplant survivor. In 1990 he was diagnosed with Acute Myleloid Leukemia (AML), underwent two years of chemotherapy and, in 1992, received his transplant at Johns Hopkins University. He is currently being treated for Myeodysplastic Syndrome. His counts are all low. He is still in remission. We would like to try IP$_6$ with inositol. Our question is with an average platelet count of 30, could the reduction of platelet aggregation (as described on pp. 84-85 of Dr. Shamsuddin's book) be harmful to him, cause bleeding, or interfere in any other way with his platelet functioning? Are there any other concerns we should have using IP$_6$ because of his low counts? Thank you, in advance, for your assistance,  K.K.*

REPLY: Each year 5,000 to 6,000 new cases of AML are diagnosed in the United States. This illness originates in myeloid cells of the bone marrow. Normally, upon diagnosis, bone marrow is completely replaced by leukemic cells. This disease responds well to treatment and is curable in both children and adults. AML may happen at any age. Fortunately, IP$_6$ has been shown to be effective against at least one leukemia cell line, according to a 1992 study by Dr. Shamsuddin, published in *Cancer Letters* (64: 195-202).

The cause of this illness is unknown; however, exposure to radiation, certain pesticides, and some chemotherapy or non-chemotherapy drugs may induce AML. The most significant manifestations are due to failure of bone marrow to produce normal blood cells. Hence, we find anemia, low white blood cells and low platelet counts. The most common symptoms include:

- Fatigue
- Weakness
- Paleness
- Bleeding
- Fever and infection
- Bone pain in arms, legs, or back

A simple blood count may be performed to establish the diagnosis. Leukemia cells can be seen and recognized under the microscope. A bone marrow test should also be performed. Since most patients are very ill at the time of diagnosis, other tests and procedures, such as blood tests, may be indicated.

Chemotherapy has significantly changed the outcome of these patients. AML is curable in 50 to 60% of cases. It is critical that this disease be managed by a well experienced oncologist or hematologist with a good insight into this illness.

We would generally advise trying $IP_6$ with inositol at a low dose and checking your husband's platelet count, his PT, and his PPT at least monthly. The normal range for platelets should be 200,000 to 350,000 per 100 ml. Therefore, 30,000 is obviously too low and must be tracked carefully over time by a trained hematologist. A Megakaryocyte Stimulating Factor may also be appropriate here. (Megakaryocytes are the cellular precursors to platelets.) We don't know whether this treatment is considered experimental or whether it even makes sense here in the absence of additional clinical data, since if all white and red blood cell counts are low maybe the marrow has not come back the way it should, and stimulating only the megakaryocytes might be useless. Nevertheless, if the baseline count of 30 remains stable over several months and there are no other coagulation problems then we would raise the dose of $IP_6$ with inositol systematically into the normal range over a six-month period while continuing to do standard Bleeding Time, PT, and PTT tests every month.

# MORE QUESTIONS ANSWERED ABOUT IP$_6$ WITH INOSITOL

## AUTO-IMMUNE DISEASE

### *Biliary Cirrhosis*

DEAR DR. COLES: *I read your article on IP$_6$ with inositol and am very interested in adding it to my supplement regimen. It sounds very exciting.*

*However, I have an autoimmune liver disease, primary biliary cirrhosis, in which immune cells destroy the small bile ducts of the liver. Therefore, I'm concerned that IP$_6$ with inositol would increase that activity.*

*Do you know if my concern is appropriate or valid? It is so difficult to find any practitioner who knows much about this issue. And, because I'm in an HMO, my access is particularly limited.*

*Thank you for any information you have or to which you could refer me. Sincerely, B.G.*

**REPLY:** We don't think that IP$_6$ with inositol would exacerbate your disease. Since IP$_6$ is in cereals, it is perhaps contraindicated in conditions where one should not eat cereals; and there are not that many conditions. Even among persons suffering celiac sprue, which is related to certain cereals that contain gluten, there are other cereals not containing gluten but having IP$_6$ that can be consumed.

## USE DURING PREGNANCY

DEAR DR. COLES: *I read your article in* **The Doctors' Prescription for Healthy Living**. *My wife is 39 years old, approximately 18 weeks pregnant with our second child and was diagnosed with breast cancer. She had a lumpectomy at Mass General Hospital on June 1st with nine positive lymph nodes and is scheduled to start chemotherapy with adriamycin/ cytoxan on July 7th. Should she take $IP_6$ with inositol?*

*What would be the pros and cons for her? Any advice that you could give us would be greatly appreciated.*
*C.M.*

DEAR DR. COLES: *I read your article on $IP_6$ with inositol in* **The Doctors' Prescription For Healthy Living**, *and found it very informative. My question is: If I'm pregnant, is $IP_6$ still safe to take?*
*Thank you, R.S.*

**REPLY (TO BOTH):** It is fine to use $IP_6$ with inositol during pregnancy. Don't forget, you ingest $IP_6$ in foods everyday. In this case, we can help to treat her breast or other cancers without harming the fetus. It is a win-win situation. Our recommended dosage is up to 15 capsules daily (see pages 88-89 for information on how to obtain the recommended formulas).

## HOW DOES $IP_6$ WITH INOSITOL COMPARE TO OTHER NEW CANCER DRUGS?

DEAR DR. COLES: *I read, with considerable interest, your article entitled "$IP_6$: The Anti-tumor Pill" in a recent issue of* **The Doctors' Prescription for Healthy Living**.

*While $IP_6$ seems to have great potential, so far, the studies have been only with animals. Of course, the same can be said about the newly formulated chemotherapy drugs now being touted in the press. In fact, Dr. Judah Folkman, the pioneer behind these compounds, has stated that all he*

*knows at this point is that " . . . if you have cancer and you're a mouse, we can take good care of you."*

*The question then becomes, based on the murine studies, how does IP$_6$ compare to the new supposedly anti-angiogenesis compounds in terms of potential efficacy? Please provide your unbiased professional opinion and the reasons supporting it.*

*Sincerely yours, A.T.*

**REPLY:** An excellent question. IP$_6$ with inositol is a natural agent that is safe and is already available. The experimental evidence is overwhelming and has been conducted worldwide by many researchers. Meanwhile, clinical and anecdotal reports are coming in that also suggest that it is effective. Furthermore, IP$_6$ with inositol has been investigated for the last 14 years, and over two dozen studies have been conducted by investigators both in and outside the United States at more than a dozen different laboratories. We submit that there is no other anti-cancer substance, anti-angiogenesis components included, that has been shown to be so effective, has undergone such rigorous testing, and with such consistently reproducible results. Animal studies do, in fact, bear human relevance. They are the basis for our entire regulatory programs now in place to weigh the risks and benefits of various compounds for their cancer potential.

Unfortunately, Dr. Folkman's astounding results could not be independently reproduced by National Cancer Institute nor any other investigators until February of this year when NCI's investigators showed that Endostatin demonstrated some activity against tumors in laboratory mice. This agent in combination with Angiostatin, another agent developed by Dr. Folkman, may be able to completely eradicate tumors in mice. However, Bristol-Mayers Squibb Company which licensed Angiostatin from EntreMed, which holds the patent, announced that it would halt development after three years of work. Therefore, many scientists remain skeptical. However, as we mentioned, the reproducibility of IP$_6$'s anti-cancer action has been documented by over a dozen laboratories during the past decade. Another

point of difference between $IP_6$ with inositol and Dr. Folkman's study is that $IP_6$ with inositol has been effective not just in rats and mice, but also against human cancer cells in the lab and human tumors grafted in mice, whereas Dr. Folkman's work deals only with tumors in mice. Thus, $IP_6$ with inositol has been shown to be effective in three different species. Anecdotal and clinical reports, from patients reported in this book, further substantiate these findings.

### How Can We Trust the Studies?

DEAR DR. COLES: *As a cancer survivor, I read with some interest your article in the Doctors' Prescription concerning $IP_6$ with inositol. However, I am concerned with the limited evidence, much of which comes from the party promoting the product for profit, i.e., Dr. Shamsuddin. I certainly have no desire to cast any doubts on the good doctor's data, but can you advise me that the published information is in fact unbiased and accurate concerning its tumor-reducing properties? Has there been totally independent testing?*

*Your comments would be very much appreciated. Thank you.*
*Sincerely, R.B.*

**REPLY:** The studies on $IP_6$ and $IP_6$ with inositol go back many years and come from a variety of resources, including researchers from Harvard in the 1950s, and, today, researchers worldwide. Dr. Shamsuddin has been the pioneer and the prime mover in popularizing $IP_6$ with inositol regarding cancer treatment, but he is by no means the only researcher who has validated the amazing anticancer properties of this natural food supplement. In fact, scientists worldwide have time and again convened conferences to discuss $IP_6$'s important contributions to human health, as in the case of the 1998 Kyoto Conference, and to alert the world to the important health benefits to be derived from $IP_6$ with inositol. We look at the "weight of the evidence." When every single study by over a dozen scientists working at independent laboratories around the world demonstrates the same results, there is something going on worth noting. We have consistent lines of evidence starting with

the test tube, experimental *in vivo* studies, and now a growing number of doctors' and health professionals' clinical reports. We believe that IP$_6$ with inositol may have a broad-spectrum effect on many cancers.

Based on clear-cut experimental evidence and accumulating clinical and anecdotal evidence, we encourage readers to use IP$_6$ with inositol for prevention and treatment of cancer for the following reason: IP$_6$ with inositol has extremely positive experimental support, while it has no known complications. We believe that all people whether they have cancer or are interested in its prevention should be taking IP$_6$ with inositol daily. Furthermore, we, ourselves, have no financial ties or interests in any IP$_6$ with inositol products. (See also our reply concerning IP$_6$ with inositol and the new cancer drugs, pages 59-61.)

## DOES IP$_6$ WITH INOSITOL HAVE DRUG OR NUTRIENT INTERACTIONS?

DEAR DR. COLES: *I read your article on IP$_6$ in* **The Doctors' Prescription for Healthy Living**. *My father is an 80 year old who has had several strokes, a heart attack, and has diabetes. He has had colon cancer and bladder cancer which has been removed surgically. Mentally, he's OK. He takes the following medications:*
- *Furosemide*
- *Fosinpril*
- *Amiodarone*
- *Aspirin*

*He also takes acidophilus and a multiple vitamin.*

*His doctors have now determined that there is nothing further they can do for him in treating the bladder cancer which has reoccurred around his ureter.*

*I was hoping to have him start on IP$_6$ with inositol. My parents, of course, are very leery of anything their doctor does not tell them to do, and their doctor has never heard of IP$_6$ with inositol.*

*Must he stop taking aspirin if he takes IP$_6$? I don't know what their doctor will say about this.*

*Can you please tell me whether you see any conflicts with $IP_6$ with inositol and the medications I have listed above?*
*Thank you very much for your help.*
*Sincerely, L.S.*

**REPLY:** It is always wise to check with your doctor before using any nutritional supplement or changing your diet in any way, especially if you are using other medical drugs. We believe that $IP_6$ with inositol may help your father to lower his dose of aspirin (see also this page below and pages 64-66), and that it will certainly help to protect him from any recurrences of his cancer and to fight his existing bladder cancer. Furthermore, his blood's coagulation parameters, no doubt, are tested as part of routine laboratory tests, and if there are any changes, his doctor will note them. $IP_6$ with inositol has no known nutrient or drug interactions.

### $IP_6$ with Inositol and Blood Pressure

DEAR DR. COLES: *I saw your article on $IP_6$ with inositol in* **The Doctors' Prescription for Healthy Living** *magazine. I was wondering if you could tell me what $IP_6$ does or might tend to do with blood pressure. I have read that ginger may tend to increase blood pressure (even if only a slight amount), and therefore I do not take it.*
*Thank you, R.M.*

**REPLY:** $IP_6$ with inositol is not likely to increase your blood pressure; if anything, it will help to keep it normal, as inositol helps to reduce anxiety and the combination has excellent benefits on cholesterol and triglyceride levels (see also page 80).

### Coumadin, Aspirin, or Other Blood Thinner Interactions?

We have grouped together these letters and answered them all at the end.

DEAR DR. COLES: *I've read the articles on IP$_6$ with inositol in the recent publications of **Doctors' Prescription for Healthy Living**. I am very interested in IP$_6$ with inositol, as I have a blood disorder. I don't have the clinical name for it, but I have poor clotting factors as well as thin blood.*

*The doctors have me on a #5 tablet of Coumadin, as I don't tolerate higher doses. My doctor would put me on something else, but because of low platelets, he is sticking with the Coumadin.*

*Could IP$_6$ with inositol be beneficial to me as an alternative to Coumadin? Please advise me if it is possible, and if I had information as to how IP$_6$ with inositol works, possibly my physician would allow me to try it. I really would like to use a different method of keeping my blood disorder under control. I've been on Coumadin 3$^1$/2 years now.*

*Many thanks for your efforts in my behalf.*
*Yours truly, A.G.*

DEAR DR. COLES: *I read an article on IP$_6$ with inositol which had your name at the end. After reading this I was wondering if I can take IP$_6$ with inositol if I am taking Coumadin. The reason I am asking is because they are both blood thinners. Thank you for taking the time to answer my question. V.M.*

DEAR DR. COLES: *Thank you for your splendid article on IP$_6$ with inositol in **The Doctors' Prescription for Healthy Living** (Vol. 2, No. 4). The news on IP$_6$ with inositol is most exciting.*

*I am a reasonably healthy 79 year-old male whose only prescription drug is TICLID at 250 mg which I take twice daily because of TIA's [transient ischemic attacks, or mini-strokes] three years ago. I take a full range of vitamins and minerals and saw palmetto for an enlarged prostate, all of which appear to be quite effective.*

*My internist (whom I greatly admire) is a traditional medical doctor who may not appreciate a substance such as IP$_6$ with inositol. He is also my primary physician. With this background, how can I investigate IP$_6$ with inositol properly?*

*Will the TICLID, which is a blood thinning drug that I am using as a substitute for aspirin, counteract the benefits of IP$_6$ with inositol?*

*I live in La Jolla, California. Is your office anywhere near La Jolla? I would appreciate hearing from you.*
*Sincerely, A.F.*

DR. COLES: *This concerns a statement you made in an article published in **The Doctors' Prescription for Healthy Living** where you discussed IP$_6$ and mentioned, at the very end of the article, that "persons taking aspirin, however, should refrain from taking both aspirin and IP$_6$ because of the complications associated with aspirin." Since I'm one of the many who takes aspirin and would also like to take IP$_6$ with inositol, I'm interested in your admonition. I called the lab where IP$_6$ with inositol is made (the phone number is on the bottle of IP$_6$ with inositol), and they don't seem to know anything about any problem with aspirin. Could you please inform me as to where you learned of the "aspirin connection" and also elaborate exactly what your statement means, as it isn't clear (to me and others) what it really means. If you refuse to respond to me, you could at least let the lab (that makes IP$_6$ with inositol) know, so that they could inform those who may call in asking about your comment in the article cited above.*
*R.R., University of Oklahoma, Norman, OK*

**REPLY (TO ALL):** IP$_6$ is not an anti-coagulant, as Dr. Shamsuddin has reported in his book, *IP$_6$: Nature's Revolutionary Cancer-Fighter*. Coagulation is the ability of blood to clot when it is outside the blood vessel, he notes. On the other hand, thrombosis is abnormal clot formation within blood vessels. The tendency of blood platelets to clot certainly predisposes to thrombosis, but thrombosis may happen due to other factors as well; a key event is increased stickiness of the platelets. There is no evidence that IP$_6$ with inositol causes the blood to be "thin." Dr. Ivana Vucenik of the University of Maryland presented a paper at the 1998 Kyoto Symposium that IP$_6$ is even more effective than aspirin in preventing the key steps of thrombosis. Since aspirin has a tendency to cause irritation of the stomach, and IP$_6$ is absorbed from the stomach, it is prudent that the two not be ingested simultaneously. The problem is that of aspirin, not IP$_6$ with inositol. Additionally, owing to better safety of IP$_6$ with inositol, it could be used potentially in lieu of aspirin. For all persons on any medications,

inform your doctor and work together, so that the proper blood parameter tests may be done. Eventually by working with your doctor, you may be able to lower the dosage of your medication.

### Calcium D-Glucarate

DEAR DR. COLES: *I read with eager anticipation about your work with the IP$_6$ with inositol formula. I am planning on taking it, but before I do, I would like to know if you think it will have a negative effect with any other nutrients I am taking, specifically calcium D-glucarate (a cellular detoxifier).*

*Also, please let me know if you have a web site.*
*Sincerely, M.*

**REPLY:** To our knowledge, there shouldn't be any interactions whatsoever between the two. Dr. Coles's website is www.grg.org, while that for the Freedom Press is www.freedompressonline.com.

## IP$_6$ WITH INOSITOL AND PETS

### Feline and Canine Mammary Cancer

DEAR DR. COLES: *I read your article taken from **The Doctors' Prescription for Healthy Living** newsletter. I'd like to ask you please whether you feel IP$_6$ with inositol can be used as an anti-tumor medication in pets? I have a cat that I love very much. There were two small tumors on two of her breasts. The veterinary-surgeon recommended she have the entire mammary chain removed surgically around January of this year, which I opted for. I don't know if the cancer is growing or if it is in remission as of now. I have her on two homeopathic remedies as well as other mineral vitamin supplements and Essiac. She appears to be fine. Are there are any detrimental effects taking IP$_6$? Would you happen to know the dosage? Would you know who would know if you are unable to answer? Thank you in advance for answering my questions.*
*Sincerely, F.C.*

DEAR DR. COLES: *I just read **The Doctors' Prescription for Healthy Living**, which I picked up from my health food store, and I had a question for you about IP$_6$. Do you believe this would be a safe product to use on my dog? (I hope you're not laughing.) My 12-year old unspayed female has just come up with a hard mass under one of her breasts. The vet did some tests and said there are some precancerous cells in the mass which could and probably will turn cancerous. I want to try and reverse or at least prevent further spreading.*

*Any thoughts would be appreciated.*

*Thank you, L.B.*

**REPLY (TO BOTH):** Our experience is that veterinary and human medicine are nearly identical with a small number of exceptions. IP$_6$ with inositol is not likely to be one of them. IP$_6$ with inositol is safe for use with canines and felines. It has been shown to be effective against various breast cancer cell cultures from rats, mice, and humans and should prove helpful. The usual recommended human dosage would be less for a smaller creature such as a cat or a dog. A dose of two capsules a day should be fine for prevention. For active cancer, we recommend that your pet be given two to three capsules three times daily mixed with its food.

### Canine Bladder Cancer

DEAR DR. COLES: *I read an abstract about recent cancer research using IP$_6$ with inositol. Would these substances have any effect at all on canines? I have a 10 1/2 year-old spayed shepherd mixed breed that was diagnosed last month with Transitional Cell Carcinoma (TCC). It is in the area of her bladder. It is beginning to "seed" itself.*

*The outlook is grim, although dogs with this disease maintain a good quality of life, in general, until one or another system begins to fail.*

*At this point, my other cyber-pals who also have dogs with TCC (it's how we connected with one another) are researching a variety of current publications regarding cancer and its treatment.*

*Any and all information you might give me would be of help. If you could refer me to someone else who might have additional input, I would appreciate it. I hope to hear from you soon.*
*Many thanks, S.T.*

**REPLY:** IP$_6$ with inositol may be used with dogs and has been shown to be helpful experimentally with bladder cancer cell cultures. Also, please avoid all pesticide-based pet flea and tick products, which as a group have been linked with canine bladder cancer. See our recommendations above for appropriate dosage. Be sure to pick-up a copy of *The Safe Shopper's Bible* (Macmillan 1995) from your local book seller or health food store by co-author Steinman and Samuel S. Epstein, M.D., for its extremely helpful safe pet product shopping charts.

### How to Obtain IP$_6$ with Inositol or More Information

DEAR DR. COLES: *I recently read a follow-up article about your article on IP$_6$ with inositol printed in Volume 2, Number 4 of **The Doctors' Prescription for Healthy Living**. I am trying to get a copy of your whole article to send to my sister in Scotland who is suffering from terminal ovarian cancer. The health food store who gave me the follow-up article (printed in Volume 2, Number 5) only has one copy of Number 4 on hand and cannot make a copy because of copyright violations. I would be extremely grateful if you could E-mail me a copy of your article to FAX to my sister in Scotland. Thanking you in anticipation of receiving it.*
*T.G.B.*

DEAR DR. COLES: *I saw something on the Internet regarding IP$_6$ with inositol. I'm interested in knowing where in the state of Florida I might obtain more information and where this product is sold.*
*Thanks for your time, P.C.*

**REPLY (TO BOTH):** To find a store nearest you carrying IP$_6$ with inositol (Cell Forté with IP$_6$™), call Enzymatic Therapy at 1-800-783-2286. See also pages 88-89.

DEAR DR. COLES: *I recently read an article by you in* **The Doctors' Prescription for Healthy Living** *on IP$_6$ with inositol, the anti-tumor pill. I am inquiring about receiving information about IP$_6$ with inositol. The magazine was not mine, so I do not have it in my possession to refer to. Someone in my family had a cancerous tumor removed and presently is cancer-free. I thought it might be good for him to take IP$_6$ with inositol. Could you please send some information on IP$_6$ with inositol and how to get it. Thank you, K.C.*

DEAR DR. COLES: *I read about your report in* **The Doctors' Prescription for Healthy Living** *in Dave Farber's Newsletter "IP." I am in Japan and wondering if it is possible to get a copy of your report on IP$_6$ over the Net or by E-mail.*
*Thanks and regards, J.C.*

**REPLY (TO BOTH):** To stay current with the latest findings on IP$_6$ with inositol, please consider a subscription to **The Doctors' Prescription for Healthy Living**. It can be ordered from the Freedom Press, 1801 Chart Trail, Topanga, CA 90290; E-mail them at info@freedompressonline.com or order at their website: www.freedompressonline.com. Subscriptions for one year are $39.95. Stay in touch with us via our website at www.freedompressonline.com. See also page 90 for complete subscription information.

DEAR DR. COLES: *We are a health-food chain in Honolulu, Hawaii. We are very interested in the IP$_6$ with inositol product. Could you FAX or send us more information on it? Also, could you tell us who manufactures and distributes this product?*
  *Can you tell me under what brands this product sold, if you have a preference, and where in Southern California it might be available?*
*Thank you, V.N.V.*

**REPLY:** As we have stressed, and will continue to do so, the only sources for the patented and proven IP$_6$ with inositol formulas are Enzymatic Therapy or PhytoPharmica. We cannot be responsible for

the adverse reactions that persons may suffer from the use of copy-cat, untested products, or the lack of benefit thereof. In fact, we have already received one report of someone who became acutely ill after using one of these copy-cat formulas. For assured safety and efficacy, stay with the Enzymatic Therapy or PhytoPharmica formulas. See Resources (pages 88-89) for information on how to obtain the IP$_6$ with inositol formulas that we recommend.

### Clinical Trials

DR. COLES: *I just read your article in* The Doctors' Prescription for Healthy Living, *Vol. 2, No. 5 about IP$_6$ with inositol. I'm a breast cancer survivor of nearly four years and director of ALIVE! Foundation, a charitable foundation funding programs for healing.*

*I would like to get more information about clinical trials (University of Maryland or others) for myself and for friends currently battling cancer.*

*One friend, specifically, has had a recurrence after a bone marrow transplant and is very ill.*

*Whom might I contact regarding trials or a recommendation for a therapeutic dosage?*

*I would greatly appreciate any assistance you might give me.*

*Thank you, J.L.*

*ALIVE! Foundation*

*1988 Wild Oak Lane; Chico, CA 95928*

*530-892-0262*

REPLY: The good news is that there is now both private and Congressional interest for funding such trials. Please visit us at www.freedompressonline.com for further updates.

*PART FOUR*

# $IP_6$ WITH INOSITOL AND OTHER CONDITIONS

As we learn more about this amazing formula, it has become clear that $IP_6$ with inositol can do far more for people's health than aid in cancer prevention and treatment. $IP_6$ with inositol has profound benefits for the prevention of kidney stones and their recurrence; anti-platelet activity; lowering cholesterol and triglycerides; prevention of free-radical related damage after a heart attack; and sickle cell anemia.

### Kidney Stones

DEAR DR. COLES: *I have been cursed with kidney stones, recurring every three or four years, since I was forty. I've heard that $IP_6$ with inositol could be helpful. Could you give me more details?*
*J.B.*

DEAR DR. COLES: *Regarding the $IP_6$ with inositol article appearing in* **Doctor's Prescription for Healthy Living** *(Vol. 2, No. 4), this report proved very interesting to me in several areas: anti-tumor and kidney stone reduction. Has the Kyoto conference come and gone along with the presentations of papers? What are the updates? What about the report by Dr. Shamsuddin regarding the "benefits on circulation by reducing the tendency of blood to clot" and its possible adverse effects in surgery (as would be the case with aspirin and aspirin-related medicines)?*

*Specifically, I am wondering about pre-op treatment of prostate cancer in the hopes of assisting with shrinkage of the tumor; the surgery is planned for early November (Gleason score 3+3; T1c; 52 years old, and otherwise in good health).*

*Also, there are several persons with chronic kidney stone development, and in serious need of complementary medicine (44 year old male, overweight but otherwise in good health and an 80-year-old female with multiple medical issues).*

*I am an R.N., so technical information is fine, as well as that which is more oriented to the lay person. Please send along whatever is available! Many thanks! S.S.*

DEAR DR. COLES: *Is there any type of herb or combination of herbs that would break up kidney stones? My 17 year-old daughter has a large low kidney stone about 7 mm in diameter. Thanks for any help you can give me. Sincerely, T.*

**REPLY (TO ALL):** For help with prostate cancer, please see our responses on pages 39 to 40. These letters provide us with the chance to expand your understanding of IP$_6$ with inositol in relation to its very important, and strongly supported, role in the prevention of kidney stones.

But, let's provide some background about kidney stones first. Urinary stones were known to the ancient Greeks, as a reference to them in the Oath of Hippocrates shows. The oldest renal stone on record actually comes from an Egyptian mummy. For obvious reasons our forefathers were better acquainted with bladder stones than renal stones until the advent of radiography. Interesting aspects of this story are the gradual decline in the incidence of bladder stones and their apparent replacement by renal stones.[29]

Medically known as *renal calculi* or *nephrolithiasis*, kidney stones affect approximately one to five percent of the population (up to about thirteen million Americans alone). Kidney stones are made up of crystals that separate from urine, often starting out as tiny specks of seemingly harmless solid material no larger than a speck of sand and

deposited in the middle of the kidney on its inner surfaces. As more material clings to the stone, its size can increase to as large as the size of a golf ball. Very often, kidney stones grow to one inch or more in diameter. Although usually lodging on the inner surfaces of the kidney, the stones are sometimes found in the bladder or ureter. Tiny stones usually are passed without pain. But, those that are 5 millimeters in diameter or larger very often cause extreme pain as they travel through the ureter with urine on their way to the bladder to be expelled.

Not only do we now know that kidney stones are caused by an abnormal accumulation of crystalline substances in the kidney urine, we also know that in 80 to 95 percent of cases, the stones are composed of calcium oxalate and calcium phosphate. This knowledge is what first led scientists in the 1950s to speculate that $IP_6$ might be helpful, as this compound is known to bind to and transport oxalates and phosphates out of the body.

Particularly at risk are persons who simply do not drink enough fluids and whose concentrated urine contains stone-forming materials.

Not all people are able to pass their kidney stones—with or without pain. This lack of passage may be the most dangerous situation of all. A kidney stone that does not pass out can block the urinary tract. This blockage will probably cause pain initially. But if medical attention is not received to identify the cause of the pain and remove the blockage, the pain is likely to gradually go away over a few days time. Don't be fooled by this lull in the kidney stone wars. This lack of pain may cause the sufferer to think the crisis has passed when, in fact, the kidney that has been blocked by the stone has shut down. A kidney stone can even rupture the collection system of the kidney. If left untreated, in just a few days this shut down can lead to permanent loss of function in that kidney.

There appears to be an increase in the number of cases of kidney stones in recent years—probably due, in part, to changing dietary habits. About 7 to 21 people out of every 10,000 (or less than two tenths of one percent) of the population will have a kidney stone attack each year (although the percentage of persons who are afflicted in their lifetime is substantially higher).

In 1985 there were 1 million cases of kidney stones in the United States. These account for about 7 to 10 of every 1000 hospital admissions (or nearly one percent). Four out of five kidney-stone cases (80 percent) are among men; while only 20 percent are women. Those persons between the ages of 35 to 50 are in their peak stone-formation period.

Also, there is a recurrence of the painful event in about 70 to 80 percent of cases once a person suffers their first-stone attack. After the first kidney-stone attack occurs in a person, they have a cumulative 10 percent chance per year of forming another stone (if no other stones are present at the time of the first stone attack). This translates into a 50% chance over a 5 year period of time. Family genetic tendencies can increase this risk. The younger people are when they have their first kidney-stone attack the greater their personal risk is for having additional attacks. Historically, about 60 percent of individuals who have experienced one kidney stone will develop another within 7 years. Thus, prevention is extremely important to anyone who has suffered from the formation of kidney stones.

Studies show the amazing benefits IP$_6$ with inositol holds for sufferers of kidney stones.[30, 31, 32] We believe that IP$_6$ with inositol presents a tremendous opportunity to prevent kidney-stone formation naturally.

"Studies of population groups point to the relationship between diet and kidney stone formation," writes Dr. Shamsuddin in his book. "Since the late nineteenth century, there has been an increased incidence of kidney stones in Europe and North America, with a similar rise in incidence observed in Japan since World War II. Many experts attribute this rise to changing dietary habits, particularly consumption of foods low in IP$_6$."

The case for the role of diet and particularly IP$_6$ in the prevention of the formation of kidney stones can be demonstrated most clearly by closely examining the South African population. We know from comprehensive sampling surveys, although South African blacks experienced some changes in their diets as they moved from the rural to urban areas of the country, not all aspects of their diet changed. In fact, some of their dietary habits at one time seemed to provide precisely the right phytochemicals for kidney-stone-free living.

We know that the type of bread South African blacks traditionally consumed was made from unrefined whole grains. Now, we see that the South African blacks are eating more white bread made with refined grains which have relatively low concentrations of naturally occurring $IP_6$. Another interesting aspect of the traditional black South African diet is the predominance at one time of dried legumes and corn. We also know that corn is the cereal grain with one of the highest $IP_6$ concentrations. Surveys have also shown that the amount of corn-based porridge consumed by South African blacks is equivalent to about 680 grams (or more than one pound) of corn per person per day! "Given the fact that corn may contain up to six percent $IP_6$, that is 40.8 grams of $IP_6$ per day," writes Dr. Shamsuddin.

In the 1970s, these distinct dietary features of the traditional black South African diet served well to reduce their occurrence of kidney stones. Dr. Monte Modlin is one of the world's leading kidney stone experts who has been based out of the Medical School of Cape Town. He examined kidney stone occurrence among blacks and whites during nine years between 1971 and 1979. While about one in five-hundred white patients admitted to the school's main teaching hospital had kidney stones, that figure was only one in about 44,300 blacks!

Unfortunately, since that time, South Africa's urban black population has continued to radically change its dietary habits. In 1987, researchers from the Department of Geology and Geochemistry, University of the Orange Free State, Bloemfontein, South Africa, found a statistically significant rising trend in the prevalence of renal stones in blacks, accompanied by changes in the ratios of the major stone-forming constituents, while both factors remained unchanged in white patients.[33] The profile of renal stones in blacks was becoming substantially different from that of the other previously reported surveys and was approaching that of white city dwellers according to the report. A change in the dietary patterns in blacks is occurring which is also reflected in an increasing incidence of ischemic heart disease and which may also be responsible for the observed changes in renal stones," the researchers concluded.

Thus, as South African blacks continue to move away from their traditional diet, the evidence has become increasingly clear that kidney stones can be prevented, and that specific phytochemicals, including IP$_6$, can play a major preventive role. We believe that all persons at risk for kidney stones would benefit tremendously from daily use of IP$_6$ with inositol.

Historically, our review of the medical literature shows that IP$_6$ was used in humans as early as 1958 to prevent and treat kidney stone formation. Dr. Philip H. Henneman and his associates at the Harvard Medical School and Massachusetts General Hospital in Boston successfully used IP$_6$ to treat a condition associated with a high frequency of kidney stones. In this study, published in *The New England Journal of Medicine*, these investigators selected 224 men who had normal blood calcium values, but, nevertheless, increased calcium in the urine.[34]

They were given 8.8 grams of oral sodium phytate (a salt of IP$_6$) daily, which normalized their urinary calcium. Ten of these patients received prolonged therapy (about two years) with an 80 to 90 percent effectiveness rate in preventing the formation of kidney stones.

More recently, there seems to be a re-emergence of interest in treating and preventing the recurrence of kidney stones by supplementing the diet with capsules of IP$_6$ with inositol. Professor F. Grases of the University of the Balearic Islands, off the Spanish coast in the Mediterranean Sea, recently conducted a study on the treatment of kidney stones by IP$_6$. He presented his data at *The First International Symposium on Disease Prevention by IP$_6$ and Other Rice Components* in Kyoto, Japan, June 8-9, 1998, showing a statistically significant decrease in kidney stone formation in 30 patients taking as little as 120 milligrams of IP$_6$ per day.

At press time, Dr. Grases has accumulated some 500 patients whom he has been following for seven years, and the recurrence rate in patients using IP$_6$ is significantly lower than the control group.

Dr. Shamsuddin points out that diets containing high amounts of IP$_6$ (rice bran) have also been used to treat hypercalciuria and kidney stones. "It is definitely easier to take a small amount of the pure IP$_6$ in tablets or capsules rather than gorging on enormous quanti-

# PREVENTION IS IMPORTANT
# FOR KIDNEY STONES

Experts say that the easiest step to take for prevention of kidney stones is to increase *hydration*. This applies to sufferers of all types of kidney stones. **Drinking very large amounts of water—two or more quarts per day—is probably the most important step in reducing stone formation.** It is recommended that sufferers increase their urine output to at least 2 quarts per 24-hour period. Drinking 2 to 3 quarts per day may reduce recurrence of stones by up to 90 percent. Initially many kidney stone sufferers may find it difficult to raise their fluid intake to this level. However, with a consistent conscious effort a person will develop a taste for water. After about a month their body will readjust its normal level of hydration. Once this new norm has become established, a person will start to feel thirsty whenever their fluid intake falls below this level. One kidney stone sufferer says: *"I like water now. You acquire a taste for it."*

High calcium in urine can be caused by too much salt in a person's diet. Salt causes excretion of larger amounts of calcium and thus increases calcium in the urine. Increasing a person's intake of water will reduce the relative concentration of calcium in the urine and thus reduce the risk of crystal formation and kidney stone formation.

Additionally, persons prone to the most common type of kidney stones (calcium oxalate) may find it advisable to cut back on foods with high oxalate levels such as those listed below to help prevent future stone formation:

- apples
- asparagus
- beer
- beets
- berries, various
- black pepper
- broccoli
- cheese
- chocolate
- coffee
- cocoa
- cola drinks
- collards
- figs
- grapes
- ice cream
- milk
- oranges
- parsley
- peanut butter
- pineapples
- spinach
- Swiss chard
- rhubarb
- tea
- turnips
- yogurt

Stone sufferers should consult with their doctor, of course, but in most cases, these foods can be eaten in limited amounts.

ties of otherwise bland rice bran," he writes in his book. Most recently, Diane, a woman in her thirties from Northern California, was told that she was suffering both uterine tumors and kidney stones. The pain from the stones was excruciating at times. In February, 1998, she went in for a pap smear. That was when her doctors discovered she was suffering from a grapefruit-sized uterine tumor. The tumor was surgically removed, but her kidney stones remained; the diagnosis was confirmed with X-rays.

"I spoke with a friend who said she was taking 16 to 18 capsules a day of IP-6 with inositol and that it helped her to get rid of her kidney stones," Diane recalls. "So I began to take IP-6 with inositol, too. Ten months later I had to go back and see if I had healed from my surgery. The doctor checking my X-rays for kidney stones told me she must have had the wrong set. There were no kidney stones, inflammation or anything resembling them remaining in my kidneys. I've had no problems since. The only thing I did differently was to take IP-6 with inositol. I was so excited and amazed. It was like winning the lottery. I did not want to have any more painful kidney attacks; now, I don't. They are all gone. I also feel more well protected against the recurrence of my uterine tumors."

We truly believe that, based on the available evidence, anyone who has suffered from kidney stones should be using IP$_6$ with inositol. Solid scientific evidence shows that it is an ideal treatment for preventing the formation of kidney stones. The recommended dosage is two capsules of **Cell Forté with IP$_6$ and Inositol** or **Cellular Forté with IP$_6$ and Inositol** twice per day, once before breakfast and once between meals, best taken on an empty stomach (see pages 88-89 for information on how to obtain this formula).

## Anti-platelet Activity

DEAR DR. COLES: *My doctor says my blood tends to clump together, which could increase my risk for a heart attack or stroke. What will taking IP$_6$ with inositol do to this condition?*
*H.H.*

**REPLY:** Preventing blood clumping is important to all persons because thrombosis can lead to circulatory blockages that cause heart attack or stroke. Research shows that $IP_6$ with inositol has extremely positive benefits on circulatory health. In fact, some experts believe its powers to prevent heart attack or stroke may someday be proven to rival that of aspirin. Dr. Shamsuddin has worked closely with Drs. Ivana Vucenik and John Podczasy, and together they have studied the ability of $IP_6$ to inhibit platelet aggregation or clotting.

The doctors initially employed an *in vivo* model and then did an experiment with human whole blood *in vitro*.

In their study, they prepared a special drinking-water mix with two percent $IP_6$ which was consumed by laboratory rats for some ten months. This is not very much and would equal only about one to two grams (1,000 to 2,000 milligrams) of $IP_6$ in a typical 150-pound human.

During this period, the animals that received the compound showed markedly improved circulatory health. On average, the animals experienced a 45% inhibition of platelet aggregation, reports Dr. Shamsuddin.

Next, the scientists took human blood from healthy volunteers (Dr. Vucenik herself being one of them). Aggregation of the blood cells, their tendency to "stick," was markedly inhibited by $IP_6$. In fact, adding more $IP_6$ produced a larger reduction in the tendency to aggregate. Various substances were added to the blood that would cause it to clump. But $IP_6$ caused anywhere from 50% to complete inhibition of clotting no matter which compounds were used.

The advantage of $IP_6$ with inositol over aspirin, however, is the complete safety and lack of any gastrointestinal irritation. We believe that one very promising area of research in the future is to examine the role that $IP_6$ with inositol can play in reducing the risk of heart attack and stroke. We look forward to human clinical trials, though, to the best of our knowledge, the major focus right now will be to examine the role of this formula in its prevention and treatment of cancer. Take two to three capsules of our recommended formula twice daily.

## Lowering Cholesterol and Triglycerides

DEAR DR. COLES: *My cholesterol is too high. So are my triglycerides. Does $IP_6$ with inositol have an effect on these?*
T.C.

**REPLY:** An elevated level of total cholesterol and triglycerides are major risk factors for atherosclerosis and coronary heart disease. Again, however, $IP_6$ with inositol may offer important help in reducing levels of cholesterol and triglycerides.

In their 1990 work at the Linus Pauling Orthomolecular Institute of Science and Medicine, Dr. Raxit Jariwalla and colleagues evaluated the effect of dietary of $IP_6$ on cholesterol. The Jariwalla team found that even though the animals were fed a cholesterol-rich diet, the addition of $IP_6$ helped tremendously; their cholesterol levels went down by 19% and triglycerides by 65% when the compound was added to the diet. The equivalent human dose would be approximately the amount used for the medically prescribed cholesterol-lowering drug Questran (cholestyramine resin).

It should also be noted that $IP_6$ was without a significant effect on the body's levels of minerals, such as zinc and copper. Indeed, the major effect of $IP_6$ was to improve the zinc to copper ratio. This is an important finding. People with elevated cholesterol often have levels of zinc that are too high, relative to the amount of copper in their tissues. This action, however, occurred only when animals were consuming cholesterol-rich diets. When their diets were low in cholesterol, $IP_6$ had no effect whatsoever. Another important findings is that the other lower IPs, or metabolites of $IP_6$, helped to remove calcium from the arteries. This is an extremely important finding for the prevention of heart attack or stroke, since calcification is a prime cause of high blood pressure and circulatory disease.

## After a Heart Attack

DEAR DR. COLES: *I have had a heart attack very recently. I also have liver cancer. I know that IP$_6$ could be helpful with my cancer, but what about my heart?*
*J.N.*

REPLY: Besides its many other documented benefits, IP$_6$ is a profoundly powerful antioxidant. Indeed, it has been noted that IP$_6$ is such a highly-charged antioxidant that it can chelate metal ions such as iron and calcium and scavenge hydroxyl radicals (OH$^-$). But what many health professionals, especially emergency room physicians, are learning is that the antioxidant function of IP$_6$ may make it extremely valuable for controlling the damage done to the heart muscle (myocardium) during heart attacks.

To gain a better grasp of this important attribute, it's useful to examine the sequence of events that occurs within the myocardium in heart attack survivors. First, we have *ischemia*, a technical term used in medicine that indicates there has been an interruption of circulation or flow of blood to the tissues, organ, or a region of the body. This interruption is due both to clots and vessel constriction. Tissues of the heart region suffer necrosis and die off. The longer that ischemia lasts, the greater the die-off will be of heart muscle cells. The key immediately following a heart attack is to rejuvenate the heart muscle cells with fresh, oxygen-rich blood within the first six hours. Beyond this time limit, it probably means that the heart will be completely damaged, and that death of the person will follow, if it hasn't already.

Simple, you might say. But not really. Once oxygen-rich blood begins to flow into the heart region, the area is littered with dead heart-muscle cells. The technical term for resaturation of the damaged heart-muscle with oxygenated blood is called *reperfusion*. This process is a double-edged sword. Reperfusion, indeed, saves lives. Yet, it may also cause a type of damage to the heart that cardiac specialists term "reperfusion injury," especially if reperfusion is delayed or the damage to the heart is particularly extensive and acute. This

fresh blood, rich in oxygen, also brings with it free radicals. Even the very process of breathing in oxygen and related metabolism creates these tiny reactive molecules. Thus, oxygen which is necessary for life can also be toxic when uncontrolled or when the body is particularly depleted of free-radical quenchers or antioxidants. IP$_6$, as we have noted, is a particularly powerful antioxidant.

In particular, this compound is able to quench superoxides, particularly the hydroxyl radical (OH$^-$), which is implicated in the damage done to the myocardium during ischemia and reperfusion. Dr. Parinam S. Rao and colleagues used IP$_6$ to inhibit OH$^-$ formation to protect the myocardium from this paradoxical damage, according to their report in the *Annals of Thoracic Surgery* in 1991.[35]

This study examined the efficacy of IP$_6$ in preventing myocardial reperfusion injury. Three different doses were administered. Those tissues receiving the highest amounts of IP$_6$ (equaling one gram for a 150-pound human) demonstrated myocardial protection as evidenced by reduced creatine-kinase release (an excess of which indicates heart damage), improved left ventricular function and coronary flow, and decreased lipid peroxidation (a type of damage to cellular membranes that is caused by free radicals) compared with the control group. The researchers concluded, "These results suggest . . . potential use of this antioxidant in salvaging the heart from ischemic and reperfusion injury . . . Phytic acid [IP$_6$], a natural antioxidant, may provide a promising tool for protecting an ischemic heart from reperfusion injury."

Thus, IP$_6$ joins an elite group of natural substances, including grapeseed extract, pyruvate, and coenzyme Q$_{10}$, that have now been shown to have potential for reducing reperfusion injury. It makes sense, then, that daily supplementation with each of these nutrients, including IP$_6$ with inositol, may well aid not only in reducing the risk of a heart attack but in increasing the chances that, if you suffer a heart attack, you will survive, and that there will be less extensive damage to the heart muscle than otherwise expected if you were not using these key dietary supplements. We predict a time in the not too distant future when IP$_6$ with inositol will be available to emergency room physicians and cardiac specialists for use in such cases.

## Sickle Cell Anemia

DEAR DR. COLES: *I am an African-American with sickle cell anemia. I heard something about IP$_6$ being able to control this disease. Is this true? Tell me more, please.*
*R.J.*

**REPLY:** IP$_6$ with inositol may be an important aid to persons with sickle cell anemia, a disease most commonly found among African-Americans but certainly not restricted to this group. Variants of the disease are also found in people of Mediterranean descent.

First, a little background. Sickle cell disease is a chronic anemia characterized by "sickle-shaped" red blood cells. Red blood cells are normally slightly "ovoid" in shape. The disease results in destruction of red blood cells.

Experimentally, it has been observed that by lowering the concentration of hemoglobin S, sickling can be reduced, allowing the cells to survive for a longer period. By loading IP$_6$ into sickled red blood cells, there is a reduction in hemoglobin S concentration and inhibition of sickling. IP$_6$-containing resealed red blood cells have the potential to control this dreadful disease as well. "Since dietary IP$_6$ is readily taken up by cells, oral supplementation with IP$_6$ should have a beneficial effect on the hemoglobin-sickling process of red blood cells," explains Dr. Shamsuddin.

Sickle cell anemia is a group of inherited red blood cell disorders. Normal red-blood-cells are like solid doughnuts. They move through small blood tubes in the body to deliver oxygen. Sickled red blood cells become stiff, sticky, and, as their name implies, shaped like sickles used to cut wheat. When these hard and pointed red cells attempt to go through small blood capillaries, they clog the flow and break apart. This can cause pain, damage, and a low blood count, or anemia. There is a substance in the red cell called *hemoglobin* that carries oxygen inside the cell. A single point mutation in one's genetic material (DNA) produces the defect and causes the hemoglobin to form long rods in the red cell when it

gives up its oxygen. These rigid rods are what change the red cell into its sickled shape. As a result of this genetic defect, the hemoglobin of sickle cell anemia (called "hemoglobin S") has structural abnormalities that cause the red blood cells to form "crescent-like" shapes. These inflexible and distorted cells plug up small arteries and capillaries, leading to the death of tissues that they service downstream. Furthermore, since the sickled red blood cells are inflexible, they are also fragile and break down easily into small fragments—a process called "hemolysis." Even though we understand the diagnosis, the genetics (inheritance), and the pathology of this disease nearly perfectly, no effective anti-sickling therapy is currently available. Treatment for sickle cell anemia deals only with symptoms, such as the severe pain associated with the disease.

According to the Sickle Cell Information Center, in Emory, Georgia, one inherits the abnormal hemoglobin from both parents who may be carriers with the sickle-cell trait or parents with sickle-cell disease. You cannot catch it. You are born with the sickle-cell hemoglobin, and it is present for life. Sickle cell trait is carried in many nationalities, including African Americans, Arabs, Greeks, Italians, Latin Americans, and Native Americans. All persons ought to be screened for this genetic defect at birth.

A simple blood test called hemoglobin electrophoresis can be done by your doctor or local sickle cell foundation. This test will tell whether you are a carrier of the sickle-cell trait or if you have the disease. Most states now perform the sickle-cell test when babies are born. This simple blood test will detect sickle-cell disease or sickle-cell trait. Sickle-cell trait is a person who carries one sickle hemoglobin–producing gene inherited from their parents and one normal hemoglobin gene. Normal hemoglobin is called "type A." Sickle cell trait is the presence of hemoglobin "AS" on hemoglobin electrophoresis. This will NOT cause sickle cell disease. Other hemoglobin traits common in the United States are "AC" and "AE" traits.

There are three common types of sickle cell disease in the United States:

- Hemoglobin SS or sickle cell anemia
- Hemoglobin SC disease
- Hemoglobin sickle beta-thalassemia

Each of these can cause sickle pain episodes and complications, but some are more common than others. All of these may also have an increase in "fetal" hemoglobin that can protect the red cell from sickling and help prevent complications. The medication hydroxyurea also increases fetal hemoglobin.

Complications from the sickle cells blocking blood flow and early breaking apart include:

- pain episodes
- strokes
- increased infections
- leg ulcers
- bone damage
- yellow eyes or jaundice
- early gallstones
- lung blockage
- kidney damage and loss of body water in urine
- painful erections in men (priapism)
- blood blockage in the spleen or liver (sequestration)
- eye damage
- low red blood cell counts (anemia)
- delayed growth

Our blood cells contain hemoglobin that binds reversibly to oxygen. Hemoglobin delivers oxygen to all our cells, otherwise they would die of suffocation. The ability of hemoglobin to bind to oxygen, and the ease with which oxygen is released from hemoglobin, is measured on a graph or chart in the shape of an "S"—the sigmoid "oxyhemoglobin dissociation curve." A shift of the curve to the right indicates an increase in the ability of oxygen to be released from hemoglobin, reports Dr. Shamsuddin. "When oxygen is released, there is increased availability of oxygen to the tissues. We now know

that when IP$_6$ is taken in by the red blood cells, the sigmoid curve shifts to the right. Therefore, IP$_6$ makes it easier for red blood cells to deliver their oxygen." For this reason, we believe that IP$_6$ with inositol is an extremely important supplement for persons with sickle cell disease to take on a daily basis.

### For more Information on Sickle Cell Disease

Sickle Cell Information Center, P.O. Box 109, Grady Memorial Hospital, 80 Butler Street; Atlanta, GA 30335

# How to Use
# $IP_6$ with Inositol

FOR CANCER PROTECTION, reducing your risk of kidney stones, and supporting circulatory health, take two capsules of $IP_6$ with inositol twice daily about thirty minutes before meals. There are no known contraindications. You may increase your dosage up to four capsules three times daily.

Four to six grams is a safe, effective range for people with cancer. Therapeutic doses of up to twelve grams have been given without complications, and with excellent efficacy, based on clinical and anecdotal reports. This would mean taking up to five capsules three times daily or seven to eight capsules twice daily. As we mentioned some people are taking up to 10 capsules three times daily. Again, take thirty minutes before meals.

# RESOURCES

## HOW TO OBTAIN IP$_6$ WITH INOSITOL

Only two sources in North America, Enzymatic Therapy and PhytoPharmica, provide the patented form of IP$_6$ with inositol. These are the only formulations we can recommend for assured safety and efficacy.

Imitation products have sprung up, but we cannot vouch for their safety or efficacy and have, in fact, received one report from a person using one of these versions who became very sick. Please use only our recommended brands. These are the only brands that we can recommend as fully guaranteed consumer values with clinical validation.

Other companies have tried to sell products with only IP$_6$. It should be noted that it is the combination of IP$_6$ with inositol that provides best results, and that this combination is patented—and available only from Enzymatic Therapy and PhytoPharmica.

You can obtain **Cell Forté with IP$_6$ and Inositol**™ from your local health food store. To find the health food store nearest you carrying **Cell Forté with IP$_6$ and Inositol**, call Enzymatic Therapy at 1-(800) 783-2286; 825 Challenger Drive; Green Bay, WI 54311; website: www.enzy.com.

You can obtain **Cellular Forté with IP$_6$ and Inositol**™ from pharmacies and health professionals. To find the pharmacy or health professional nearest you carrying **Cellular Forté with IP$_6$ and Inositol**, call PhytoPharmica at 1-(800) 553-2370 (health professionals) or 1-800-376-7889 (consumers); 825 Challenger Drive; Green Bay, WI 54311; website: www.phytoPharmica.com.

*Each Capsule in These Formulas Contains*

IP$_6$™ (Rice)    400 mg
Inositol (Rice)   110 mg
Contains no sugar, salt, yeast, wheat, gluten, corn, soy, dairy products, coloring, flavoring or preservatives.

## HOW TO OBTAIN MACROFORCE (BETA-1, 3-D-GLUCAN)

To find a health food store, pharmacy or health professional nearest you carrying **MacroForce® Plus C**, call 1-888-246-6839 or visit the Immudyne website at www.immudyne.com. For cancer treatment take up to five 7.5 mg capsules daily. Take two 7.5 mg capsules daily to help prevent a recurrence of cancer or for prevention.

## HOW TO OBTAIN SOY EXTRACT AND REMIFEMIN

Both Soy Extract and Remifemin are available exclusively through Enzymatic Therapy or PhytoPharmica (see above or page 88 for contact information).

## HOW TO REACH DR. COLES

Please address all correspondence to Dr. Coles in care of: The Freedom Press, 1801 Chart Trail; Topanga, CA 90290 or visit our website: www.freedompressonline.com. Dr. Coles may be reached via E-mail at scoles@grg.org. The web site for the LA Gerontology Research Group is at www.grg.org.

## SUBSCRIBE TO THE DOCTORS'
## PRESCRIPTION FOR HEALTHY LIVING

For the latest updates on IP$_6$ with inositol, we recommend that you subscribe to the cutting edge publication *The Doctors' Prescription for Healthy Living* for $39.95 for 12 issues. The newsletter covers IP$_6$ with inositol monthly. Their address is 1801 Chart Trail, Topanga, CA 90290. They may be reached via www.freedompressonline.com where you may also subscribe. Or call toll-free at 1-800-959-9797.

## SUBSCRIBE TO
## THE DOCTORS' PRESCRIPTION
## FOR HEALTHY LIVING

### Yes, I want to be a smart savvy shopper. Sign me up for:

_____ 12 issues of *The Doctors' Prescription for Healthy Living*. $39.95 (Receive as a bonus: *IQ Boosters for the CyberAge*)

_____ 24 issues of *The Doctors' Prescription for Healthy Living*. $49.95 (Receive three FREE bonuses: *Cure Indigestion, Heartburn, Cholesterol, Triglyceride and Liver Problems with Artichoke Extract, The Men's Essential Guide to Prostate Health* and *IQ Boosters for the CyberAge* )

Name (Mr., Mrs., Ms.) _____

Address _____

City _____ State _____ Zip _____

**Bill My Credit Card:**
Mastercard    Visa    American Express    Discover

Card No._____

Exp. Date _____X _____
.                          (Signature)

Make checks or money orders payable to Freedom Press; mail to Freedom Press, 1801 Chart Trail, Topanga, CA 90290 or fax to (310) 455-8962 or (310) 455-3203.

## OTHER RESOURCES

Be sure to pick up two books by David Steinman and Samuel S. Epstein, M.D. The first is *The Safe Shopper's Bible* (Macmillan 1995) which helps people to purchase safe, nontoxic products for their home, including household cleaners, cosmetics, and foods. Reducing your toxic exposures will also help to dramatically reduce your cancer risk. The second is *The Breast Cancer Prevention Program* (Macmillan 1998), the first complete survey of all causes of breast cancer and the steps women can take to reduce their risks. Both books are invaluable resources.

Also, please consider purchasing *IP$_6$: Nature's Revolutionary Cancer-Fighter* from Kensington Books, available at health food stores and book sellers for additional detailed information on other health benefits to be derived from the IP$_6$ with inositol combination.

*91*

# *APPENDIX:*
# REFERENCES

1. Steinman, D. & Epstein, S.S. *The Safe Shopper's Bible*. New York, NY: Macmillan 1995.
2. Epstein, S.S. & Steinman, D. *The Breast Cancer Prevention Program*. New York, NY: Macmillan, 1998.
3. Shamsuddin, A.M., et al. "IP$_6$: a novel anti-cancer agent." *Life Sciences*, 1997; 61(4): 343-354.
4. Challa, A., et al. "Interactive suppression of aberrant crypt foci induced by azoxymethane in rat colon by phytic acid and green tea." *Carcinogenesis*, 1997; 18(10): 2023-2026.
5. Shamsuddin, A.M. "Inositol phosphates have novel anticancer function." *Journal of Nutrition*, 1995; 125: 725S-732S.
6. Shamsuddin, A.M. & Ullah, A. "Inositol hexaphosphate inhibits large intestinal cancer in F344 rats 5 months after induction by azoxymethane." *Carcinogenesis*, 1989; 10(3): 625-626.
7. Vucenik, I., et al. "Comparison of pure inositol hexaphosphate and high-bran diet in the prevention of DMBA-induced rat mammary carcinogenesis." *Nutrition and Cancer*, 28(1): 7-13.
8. Vucenik, I., et al. "Inhibition of rat mammary carcinogenesis by inositol hexaphosphate (phytic acid). A pilot study." *Cancer Letters*, 1993; 75: 95-102.
9. Shamsuddin, A.M., "Inositol phosphates have novel anticancer function." *Journal of Nutrition*, 1995; 125: 725S-732S.

10. Jariwalla R.J., et al., "Effects of dietary phytic acid (phytate) on the incidence and growth rate of tumors promoted in Fischer rats." *Nutr. Res.* 1988; 8:813-27.

11. Jariwalla R.J., et al., "Lowering of serum cholesterol and triglycerides and modulation of divalent cations by dietary phytate," *J. Appl. Nutr.* 1990; 42:18-28.

12. Thompson L.U., Zhang L., "Phytic acid and minerals: Effect on early markers of risk for mammary and colon carcinogenesis." *Carcinogenesis*, 1991; 12: 2041-5.

13. Sakamoto, S., et al. "[3H]phytic acid (inositol hexaphosphate) is absorbed and distributed to various tissues in rats." *Journal of Nutrition*, 1993; 123: 713-720.

14. Huang, C., et al. "Inositol hexaphosphate inhibits cell transformation and activator protein 1 activation by targeting phosphatidylinositol-3' kinase." *Cancer Research*, 1997; 57: 2873-2878.

15. Shamsuddin, A.M., et al. "Inositol and inositol hexaphosphate suppresses cell proliferation and tumor formation in CD-1 mice." *Carcinogenesis*, 1989; 10: 1461-1463.

16. Estensen, R.D. & Wattenberg, L.W. "Studies of chemopreventive effects of *myo*-inositol on benzo[a]pyrene-induced neoplasia of the long and forestomach of female A/J mice." *Carcinogenesis*, 1993; 14: 1975-1977.

17. Challa, A., et al., op. cit.

18. Vucenik, I., et al. "Inhibition of rat mammary carcinogenesis by inositol hexaphosphate (phytic acid). A pilot study." *Cancer Letters*, 1993; 75: 95-102.

19. Shamsuddin, A.M., et al. *Anticancer Research*, 1996; 16: 3287-3292.

20. Shivapurker, et al. *Cancer Letters*, 1996; 100: 169-179.

21. Vucenik, I., et al. *Carcinogenesis*, 1995; 16: 1055-1058.

22. Vucenik, I., et al. *Nutrition and Cancer*, 1997; 28: 7-13.

23. Thompson & Zang, *Carcinogenesis*; 1991; 12: 2041-2045.

24. Hirose, et al. *Cancer Letters*, 1994; 83: 149-156.

25. Shamsuddin, A.M. & Yang, G.Y. "Inositol hexaphosphate inhibits growth and induces differentiation of PC-3 human prostate cancer cells." *Carcinogenesis*, 1995; 16(8):1975-9.

26. Baten, A., et al. "Inositol-phosphate-induced enhancement of natural killer cell activity correlates with tumor suppression." *Carcinogenesis*, 1989; 10(9):1595-8.

27. Shamsuddin, A.M. *IP$_6$: Nature's Revolutionary Cancer-Fighter.* New York, NY: Kensington Publishing Corp., 1998.

28. Huang, C., et al. "Inositol hexaphosphate inhibits cell transformation and activator protein 1 activation by targeting phosphatidylinositol-3' kinase." *Cancer Res*, 1997; 57(14):2873-8.

29. Modlin, M. "A history of urinary stone." *S Afr Med J*, 1980; 58(16):652-5.

30. Grases, F., et al. "A new procedure to evaluate the inhibitory capacity of calcium oxalate crystallization in whole urine." *International Urology & Nephrology*, 1995; 27: 653-661.

31. Grases, F., et al. "Study of the early stage of renal stone formation: experimental model using urothelium of pig urinary bladder." *Urological Research*, 1996; 24: 305-311.

32. Grases, F., et al. "Study of the effects of different substances on the early stages of papillary stone formation." *Nephron*, 1996; 73: 561-568.

33. Beukes, G.J., de Bruiyn, H., Vermaak, W.J. "Effect of changes in epidemiological factors on the composition and racial distribution of renal calculi." *Br J Urol*, 1987; 60(5):387-92.

34. Henneman, P.H., et al. "Idiopathic hypercalcuria." *The New England Journal of Medicine*, 1958; 17: 802-807.

35. Rao, P.S., et al. "Protection of ischemic heart from reperfusion injury by myo-inositol hexaphosphate, a natural antioxidant." *Ann Thorac Surg*, 1991; 52(4):908-12.

# L. STEPHEN COLES, M.D., PH.D.

Dr. L. Stephen Coles is both a physician and a computer scientist specializing in applications to medicine. He holds degrees in electrical engineering, mathematical statistics, and computer science, as well as his clinical internship in obstetrics and gynecology from the University of Miami Jackson Memorial Hospital.

Dr. Coles is a co-founder of the Los Angeles Gerontology Research Group that was started by himself and three other scientists in the fall of 1990. The LA-GRG now meets on a monthly basis at the UCLA Medical School. Over the years, the GRG has grown to over 120 members, more than half with advanced degrees (30 M.D.'s and 32 Ph.D.'s). See the GRG Internet website at "http://www.grg.org" for more detailed information. Among his projects in the field of human longevity, Dr. Coles has worked on sequencing the human genome, as well as having performed experimental studies to scientifically validate the life-extending properties of nutrients such as coenzyme $Q_{10}$ and chromium picolinate.

# DAVID STEINMAN

David Steinman is a resident of Topanga, California. He is author or co-author of *Diet for a Poisoned Planet* (Crown 1990, Ballantine 1992), *The Safe Shopper's Bible* (Macmillan 1995), *Living Healthy in a Toxic World* (Perigee 1996), *The Breast Cancer Prevention Program* (Macmillan 1997, 1998), *Arthritis: The Doctors' Cure* (Keats Publishing 1998) and the forthcoming novel, *Bloodlands*. He is chairman of Citizens for Health and served two years on a committee of the National Academy of Sciences where he co-authored *Seafood Safety* (National Academy Press, 1991). He is publisher of *The Doctors' Prescription for Healthy Living*, one of the largest circulation health letters in the United States today. Steinman is a member of the teaching faculty at National University and the University of Phoenix. He has won awards from the California Newspaper Publishers' Association, Sierra Club, and Society of Journalists' Best of the West. He is married to the artist Terri Steinman and they have one son.